**This book is to be returned on or before
the last date stamped below.**

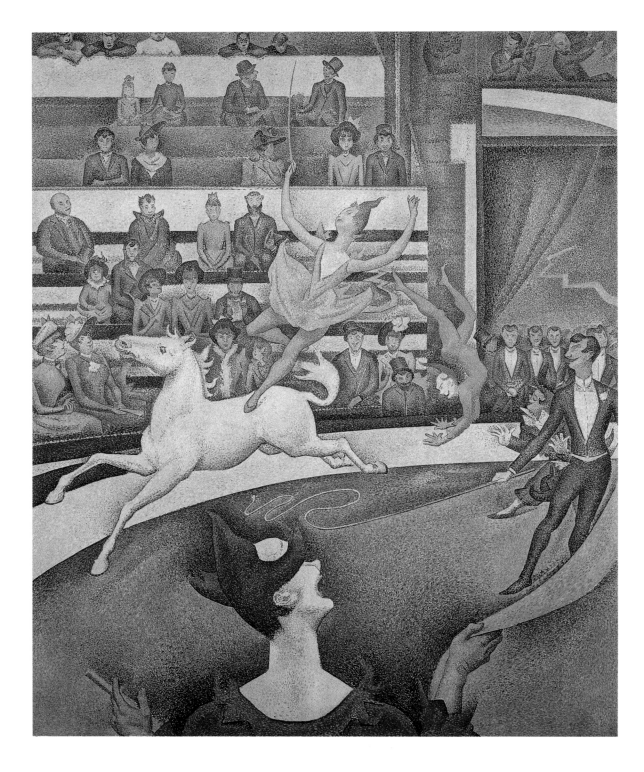

Hajo Düchting

GEORGES SEURAT

1859 – 1891

The Master of Pointillism

TASCHEN

KÖLN LONDON MADRID NEW YORK PARIS TOKYO

FRONT COVER:
A Sunday on La Grande Jatte (detail), 1884–1886
Oil on canvas, 207.6 x 308 cm
Chicago, The Art Institute of Chicago, Helen Birch Bartlett Memorial Collection, 1926.224

PAGE 1:
Lady with Parasol, 1884
Conté crayon, 48 x 31.4 cm
Chicago, The Art Institute of Chicago

PAGE 2:
The Circus, 1890–91
Oil on canvas, 185.5 x 152.5 cm
Paris, Musée d'Orsay

BELOW:
The Artist in his Studio, c. 1884
Conté crayon, 31.1 x 23.2 cm
Philadelphia, The Philadelphia Museum of Art, A. E. Gallatin Collection

BACK COVER:
Maximilien Luce
Seurat, 1890
Lithograph
Photo: Archiv für Kunst und Geschichte, Berlin

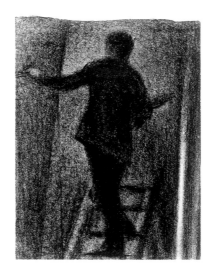

© 2000 Benedikt Taschen Verlag GmbH
Hohenzollernring 53, D–50672 Köln
www.taschen.com
© 1999 VG-Bildkunst, Bonn, for the reproductions of the works by Jules Chéret,
Maximilien Luce, Henri Matisse and Paul Signac

Editing and layout: Ute Kieseyer, Cologne
English translation: Michael Hulse, Cologne
Production: Martina Ciborowius, Cologne
Cover design: Angelika Taschen, Claudia Frey, Cologne

Printed in Germany
ISBN 3–8228–5863–3

Contents

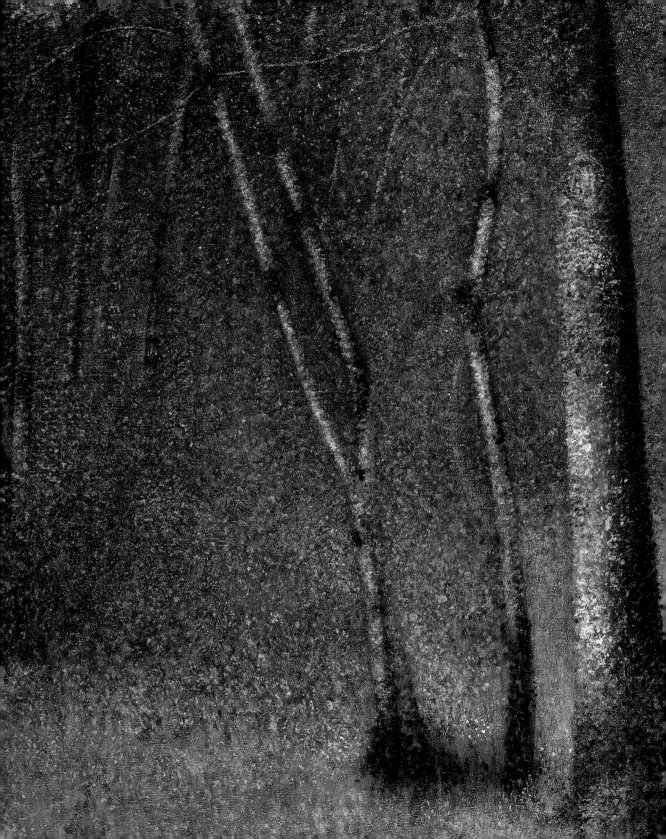

From the Academy to Impressionism

The reserved, shy, yet strangely proud-seeming young painter Georges Seurat lived a secluded life in a small studio on the Boulevard de Clichy in Paris. In comparison with other 19th-century artists such as Vincent van Gogh or Paul Gauguin, he led what appeared on the outside to be a rather uneventful life.

His passions could only be aroused on questions of art. Then he would spend hours discussing his views on painting and expounding the most recent theories of colour and art, without which, he declared, a new style of painting could no longer get by. His insistence presently made him one of the foremost figures of the new Parisian art scene which, during the 1880s, departed ever further from the old ideals of Impressionism – intuition and temperament – and sought new values in art.

The Impressionist masters such as Claude Monet, Auguste Renoir and Edgar Degas had in the meantime become part of the establishment. Their style was even imitated, in a moderated form, in Salon circles. The spontaneous, virtuoso and subjective approach of the Impressionists was no longer enough for many young painters; they sought scientific principles on which to base their art, and were therefore fascinated by Seurat's unconditional dedication to painting and his belief in verifiable rules which would give modern painting a new persuasive power.

Émile Zola of all people, formerly the advocate of Impressionism, took increasing exception in the late 1870s to the sketchy, unfinished nature of Impressionist work. In an article on Monet he declared that French painting was undergoing a crisis, for which he blamed the Impressionists: "The misfortune is that no one painter of the group has given powerful and definitive expression to the formula everywhere apparent in their works. The formula is there, endlessly fragmented, but nowhere is it applied by a master. They are all in the vanguard, but the genius has not yet been born."

This and similar criticism of contemporary painting will have confirmed Seurat's desire to put all his energy into a new mode of painting that would draw its power and charisma from its very links to the tradition of art. Little mattered to him apart from painting. The contemporary writer Arsène Alexandre left this description of the young artist: "Seurat was one of those affable thickheads who look as if they were afraid of everything but in reality fear nothing. He worked doggedly and led the isolated life of a monk in his little studio." He even kept secret for as long as possible his first and only love – Madeleine Knobloch. This

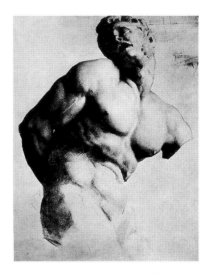

Prometheus, c. 1877
Drawing, 67 x 48 cm
Paris, Private Collection

PAGE 6:
The Forest at Pontaubert, c. 1881–1882
Oil on canvas, 79.1 x 62.6 cm
New York, The Metropolitan Museum of Art
Purchase, Gift of Raymonde Paul, in memory of
her brother, C. Michael Paul by exchange, 1985,
(1985.237)

7

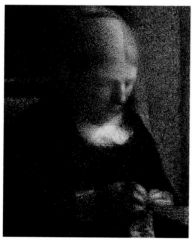

Emboidery; The Artist's Mother, c. 1882–1883
Conté crayon on paper, 31.2 x 24 cm
New York, The Metropolitan Museum of Art
Purchase, Joseph Pulitzer Bequest, 1951;
acquired from The Museum of Modern Art,
Lillie P. Bliss Collection (55.21.1)

TOP:
Aman-Jean, 1883
Conté crayon on paper, 62.2 x 47.6 cm
New York, The Metropolitan Museum of Art
Bequest of Stephen C. Clark, 1960, (61.101.16)

PAGE 9:
Young Peasant in Blue, c. 1881–1882
Oil on canvas, 46.5 x 38 cm
Paris, Musée d'Orsay

young working woman lived with him in that "little studio" in the Passage de l'Élysée-des-Beaux-Arts, unbeknown to his family and friends. It was not until after his death that his friends found out about their relationship, which had also produced a son. The boy died one year after his birth from the same infection that Seurat had succumbed to shortly before, at the age of only thirty-one. Shortly afterwards, the child's mother disappeared from the family's sight without a trace.

Georges Seurat was born into a middle-class family. His father, Chrysostome-Antoine Seurat, had worked as a legal official in La Villette, a community to the north of Paris then not yet absorbed into the city. He had saved a small fortune, and thanks to this his son was able to lead a life of financial independence; unlike artist friends such as Camille Pissarro (1830–1903), Georges Seurat never had any money worries. At the time of his birth, his father was already retired. He had lost an arm as the result of an accident, and not least because of some curious tastes he was considered an odd fellow. For most of the time Seurat's hermit-like and taciturn father lived alone in a house in Le Raincy, some twelve kilometres from the comfortable flat on the Boulevard Magenta which formed the family home.

Seurat's mother was of an old-established Parisian family, the Veillards, which had produced several sculptors since 1750. Seurat's grandfather Faivre had been a jeweller in the Rue de la Barillerie, later in the Rue Saint-Julien-le-Pauvre.

Georges Seurat was the third of four children. His elder brother Émile was a rather unsuccessful playwright, who later retired on his inheritance. His younger brother Gabriel died when he was only five. His sister Marie-Berthe married Léon Appert, an engineer at the École Centrale, who was renowned as the master of the glass-blowing workshop.

Georges Seurat decided early on to become an artist, whereupon – in contrast to his Impressionist predecessors – he embarked upon a classical training. At the age of fifteen he attended a drawing course at the municipal drawing school in the Rue des Petits-Hôtels, close to his parents' flat. There he made a friend of Edmond Aman-Jean (1858–1935/36), together with whom he was accepted by the École des Beaux-Arts in 1878. His instruction at the Academy under Henri Lehmann (1814–1882), a somewhat insignificant student of Jean Auguste Dominique Ingres (1780–1867), consisted primarily in drawing, both from plaster casts and living models. For the classicist Ingres school, line was the fundamental constituent of art, with colour being considered an irrelevance, a pretty accessory. The curriculum at the Academy reflected this belief, placing particular emphasis upon instruction in drawing and composition.

Seurat himself initially accepted this view with barely a murmur, as evidenced by his numerous life drawings and copies of casts of Greek sculptures (pp. 7, 11). Nevertheless, he used his ample free time to conduct his own artistic studies. "Much of his time he spent in the library of the Academy, looking at books, prints and photographs", recalled his friend, the painter Paul Signac (1863–1935). It was during these studies that Seurat rediscovered a book which he had already read as a schoolboy, the *Grammaire des arts du dessin* (Grammar of the Arts of Drawing) by Charles Blanc (1813–1882), the former director of the Academy and an influential art critic who subscribed to classical idealism and called for a return to the Italian aesthetic theory of the 17th century. This return to a classical ideal of art underlay the decorative programme of the Academy's chapel, for which Blanc had commissioned copies of the frescoes *The Battle of Heraklios* and *The Discovery of the True Cross* executed in Arezzo

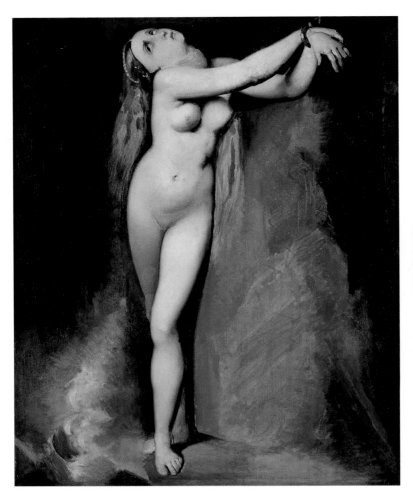

Angelica at the Rock (after Ingres), 1878
Pencil, 43 x 28 cm
Private Collection

LEFT:
Angelica at the Rock, (after Ingres), 1878
Oil on canvas, 81.4 x 65 cm
Pasadena (CA), Norton Simon Museum of Art,
Gift of Jennifer Jones Simon

by Piero della Francesca (1410/20–1492). Seurat may have made his own stud-
ies of the paintings in the chapel, which would thus have introduced him, at least
indirectly, to the Italian Early Renaissance.

Under the influence of Blanc, Seurat not only engaged more energetically
with the Academy ideal of art, but also encountered ideas and theories which
were to be of benefit in his later work. For Blanc, the painters Jacques Louis
David (1748–1825), who had founded French Classicism, and Ingres were
examples of the primacy of line and of the resulting idealization of the human
figure. At the same time, however, he also acknowledged the achievements of
Eugène Delacroix (1798–1863), whose energetic brushwork and glowing col-
ours formed an abrupt contrast to the cool manner of Ingres. In Blanc's view, the
secrets of colour, like those of music, were eminently decipherable – for Seurat,
an important thought which would have equally important consequences.

Blanc also discussed the work of Eugène Chevreul (1786–1889) and the laws
of the contrast of complementary colours, which Seurat was to study in detail at
a later date. With reference to Chevreul and Delacroix, Blanc had developed a
theory of optical mixture according to which small brushstrokes placed next to

Head of a Woman, c. 1878–1879
Oil on canvas, 28.8 x 24.1 cm
Washington D.C., Dumbarton Oaks House
Collection

The Parthenon Ilissos, 1875
Pencil, 36 x 53.5 cm
Paris, Musée du Louvre

each other would create a vibrant effect of colour in the picture. He demonstrat-
ed this principle of optical mixture in the example of the dome of the library in
the Palais du Luxembourg, which had been decorated by Delacroix between
1845 and 1847. The wonderful mixtures of colour, he noted, had been created
by Delacroix' placing brushstrokes of complementary colours next to each other
without mixing them. Prompted by this, Seurat himself analysed nine paintings
and sketches by Delacroix and copied important sections of Achille Piron's 1865
monograph on Delacroix, which cited excerpts from the painter's diary. Seurat
undoubtedly studied the technique of brushstrokes layered crosswise over each
other in Delacroix' later murals in the Paris church of Saint-Sulpice, absorbing
it into his own technique. Blanc's *Grammaire* thus offered Seurat a first con-
firmation that the principles of painting were rooted in objective laws.

Apart from his drawings, we know of only two paintings dating from Seurat's
time at the Academy. His *Angelica at the Rock* (p. 10), an oil after Ingres, clearly
falls into line with Academy conventions, while the small portrait study of his
cousin (p. 11) similarly illustrates the preferred technique of the day. Thus
Seurat starts with a chalk preliminary drawing on the golden brown-primed

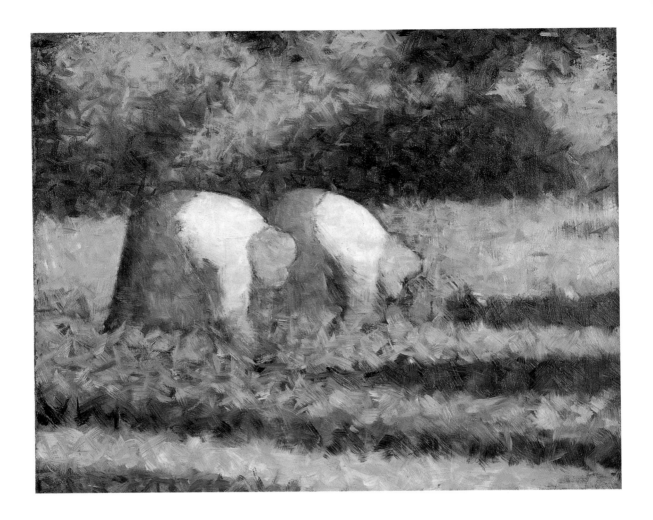

Farm Women at Work (Paysannes au travail)
c. 1882–1883
Oil on canvas, 38.5 x 46.2 cm
New York, The Solomon R. Guggenheim
Museum, Gift Solomon R. Guggenheim, 1941

canvas, then sketches a reddish underpainting and finally completes the portrait with earth pigments, whereby the highlights are painted with pastose paint and the shadows with thinned glazes. Seurat retained considerable elements of this technique later in life, including the practice of underpainting in local colours, and the conscious evolution of the final composition through numerous sketches and studies …

Seurat left the Academy in 1879 and rented a studio in the Rue de l'Arbalète, not far from the Jardin des Plantes, together with his colleagues Ernest Laurent (1861–1929) and Edmond Aman-Jean. In May of the same year, Seurat visited the fourth Impressionist exhibition. This was the first time he had seen paintings by the Impressionists, and they opened his eyes to an art liberated from the rigidities of academic rules. Following his year of military service in Brest, he rented a tiny flat at 19, Rue de Chabrol, where for two years he devoted himself to drawings and small oil sketches.

Seurat soon achieved considerable maturity in draughtsmanship. Using hard black Conté crayon, he drew on grainy Ingres paper, hatching the slightly raised parts of the paper and leaving the hollows more or less empty. This hatching

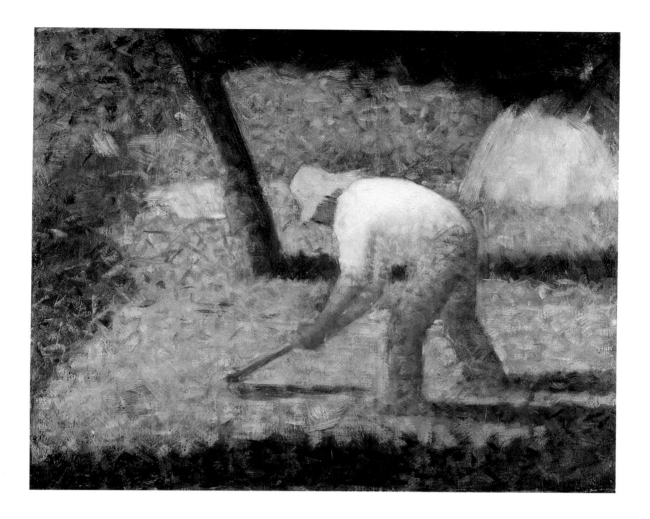

technique creates rich chiaroscuro modelling and grey tones that are full of nuances. Seurat was so aware of the mastery he had achieved in drawing that he submitted two sheets to the Salon of 1883. The portrait of his mother at her embroidery (p. 8) was rejected by the jury. But the portrait of *Aman-Jean* (p. 8) was accepted, possibly because of the more realistic method of depiction.

Even if it is difficult to arrange Seurat's drawings in chronological and stylistic order, those of his drawings characterized by clear contours are from now on increasingly joined by softly modelled chiaroscuro studies, in which the subject, normally a simple motif from the artist's Parisian surroundings, stands out in silhouette against a network of overlapping lines (p. 16). The strict stylization and simplification of the motif indicate a desire for abstraction which at this time Seurat shared only with Paul Cézanne (1839–1906). Even unprepossessing motifs are given a monumental quality by the way they are defined by lines. The figures are frequently also framed, and thus emphasized, by bright aureoles. Seurat was inspired to use this technique by Chevreul's theories on the simultaneous contrast of colours. This style can also be traced back, however, to the naïve, popular illustrated broadsheets on religious subjects from Épinal, which

Peasant with a Hoe (Paysan à la hoye), c. 1882
Oil on canvas, 46.3 x 56.1 cm
New York, The Solomon R. Guggenheim
Museum, Gift, Solomon R. Guggenheim, 1941

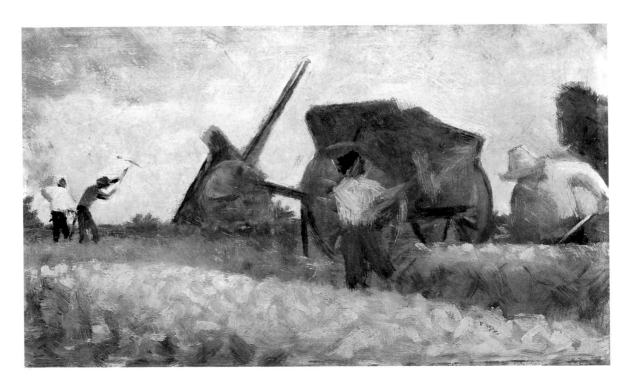

Les Ouvriers, c. 1881
Oil on panel, 15.5 x 24.8 cm
Upperville (VA), Collection of Mr and Mrs Paul
Mellon

Seurat's father collected. They had thus been familiar to the artist since child-
hood, and he must have been aware from an early age of how an image must
be simplified if it is to possess a monumental quality.

In addition to drawings, Seurat executed numerous oil sketches, or *croque-
tons* as he called them – a development of the academic sketch (French: *croquis*)
into a form of picture in its own right. These he used both to make preliminary
studies for his large paintings and as a forum for technical experimentation.
While the style of these *croquetons* is very different to that of Seurat's drawings,
and tends increasingly towards Impressionism, their themes are clearly similar.
Thus Seurat turns in his oil sketches to the portrayal of people in their everyday
environment, just as he was already doing in drawings such as *Stonebreakers,
Le Raincy* (p. 16).

The new element of realism present in such *croquetons* as *Peasant with a Hoe*
(p. 13), *Farm Women at Work* (p. 12) and *Les Ouvriers* (p. 14) is inherited direct-
ly from the founder of French Realism, Gustave Courbet (1819–1877). The
influence of Courbet is evident in particular in *Les Ouvriers* (p. 14), its theme
being a working world that was deliberately ignored by official Salon painting.
One seeks in vain, however, for any trace of social criticism in such pictures by
Seurat (in contrast to Courbet, who was always in revolt against ossified social
conditions in need of change). The figures are far too stylized for this, too close-
ly associated with the soft Impressionist style of brushwork. The tension in
Seurat's pictures arises primarily from formal criteria, such as the contrast be-
tween the massive cart and the man in front, or the repetition of diagonals.

During this early period, no other painter made so great an impression on
Seurat as Jean-François Millet (1814–1875), whose themes and compositions
he adopted. When Millet exhibited his famous painting of *The Gleaners*

(1857; Paris, Musée du Louvre) at the Salon of 1857, both the critics and the public were outraged. It was considered a provocation, an accusatory highlighting of the plight of the rural proletariat – an extreme interpretation with which Millet, incidentally, never agreed.

Around 1882–1883, Seurat alluded to *The Gleaners* in his *Farm Women at Work* (p. 12). Once again, however, this is not social criticism; it is simply an atmospheric, bright painting. The light meadow, rendered in cross-hatching, is rhythmically structured by the shadows of a row of trees that must presumably be to the right outside the picture. The light blouses strike the brightest notes and shine luminously out of the mesh of brushstrokes. The geometric composition is paralleled by the rhythmic brushwork, with its overlayered crosswise strokes, and the vibrant palette, with its rich contrasts of yellow and orange to the green of the grass, and blue to the yellow of the straw hats.

In many of his oil sketches, Seurat appears to be interested in capturing a mood similar to that found in the works of the Barbizon school, of which Millet had been a leading member. In the mid-19th century a number of artists had settled at the village of Barbizon, in the forest of Fontainebleau. They painted out of doors and attempted to capture light in their work. Their aim was an intimate revelation of nature rather than classical or ideal landscapes.

Forerunners of the Impressionists, the Barbizon painters were themselves influenced by the work of Camille Corot (1796–1875), an artist equally important for Seurat. Thus Seurat's small oil painting of *The Forest at Pontaubert* (p. 6), with its bright atmosphere made up of small dots of paint, is reminiscent of Corot's resplendent landscapes. The composition, by contrast, is strictly constructed, consisting of a few rising lines with a solid counterweight in the form of the tree on the right.

J. Aviat, an amateur lady painter and a contemporary of Corot, wrote down Corot's tips for painting from nature in her memoirs of conversations with the master, published in 1875. Since Seurat, who never came to know Corot, often referred to this text in later years, the lady painter's notes can be taken as a guide to Seurat's method of working:

"First you must feel your subject, in order, once you have grasped it, to paint it. Thereby: trust.

When you copy Nature, you always learn something.

I always try to see the work as a whole – like a child blowing a soap bubble. While the bubble is still small, it appears quite round. Then slowly the child blows it up until it is frightened that the bubble will burst. In the same way I work on all the parts of my painting at once, and bring it cautiously to perfection until, at last, I have achieved the whole effect.

I always begin with the shadows, which seems to me logical, since what hits the eye should be depicted first.

What one finds in painting, or to be exact, what I look for is the form, its entirety, the importance of the tones [...] Colour, for me, comes later, since what I enjoy above all is the harmony of the tones, while colour sometimes creates hard contrasts, which I do not like.

In a painting there is always a point of light, but it must be the only one. You can put it wherever you like: in a cloud, in a reflection on the water or on a cap. But only one tone should have this intensity."

If Seurat was increasingly being pulled towards an impressionistic portrayal of the world around him, he did not turn his back altogether upon the past. In common with many painters of his generation, Seurat turned to the examples of

Place de la Concorde, Winter, c. 1882–1883
Conté crayon and chalk on Michallet paper,
23.5 x 31.1 cm
New York, The Solomon R. Guggenheim
Museum, Gift, Solomon R. Guggenheim, 1941

Stonebreakers, Le Raincy, c. 1881
Conté crayon on paper, 30.7 x 37.5 cm
New York, The Museum of Modern Art
Lillie P. Bliss Collection

earlier masters in his search for a balanced composition. Alongside the Italians of
the Quattrocento, these included Nicolas Poussin (1594–1665), whom Seurat had
already studied and copied at an earlier date, and Pierre Puvis de Chavannes
(1824–1898), who had introduced a new monumental austerity in his wall paint-
ings. The *Young Peasant in Blue* (p. 9) and *Seated Woman* (p. 19) clearly show this
influence, which can also be detected in Seurat's large paintings. Like Puvis, Seurat
sets off a single self-contained outline against a light background. While Puvis'
figures lack vitality due to their strong stylization, however, Seurat's compositions
seem less rigid, despite their reduction to essentials.

Nevertheless, having started from a classical, Academy-propounded ideal of art, Seurat was now moving towards the contemporary style of Impressionism. Rather than simply adopting its techniques, however, he strove to grasp its very roots. In so doing, he stayed with the naturalistic themes which the older Impressionists, and in particular Claude Monet (1840–1926) and Paul Cézanne, were increasingly relinquishing in favour of a pure natural lyricism. In landscape studies, such as *Rue St-Vincent, Montmartre, in Spring* (p. 18), Seurat reproduced the effect of the light with Impressionist brushwork. The Impressionist manner of painting is closely associated with a particular repertoire of motifs. Prompted by Monet's series, a representative cross-section of which was on show at the seventh Impressionist exhibition of 1882, Seurat now devoted himself increasingly to the effects of light in the open countryside, as well as reflections in water, a favourite theme of Monet's.

Suburb, 1882–1883
Oil on canvas, 32.4 x 40.5 cm
Troyes, Musée d'Art Moderne
Gift of Pierre and Denise Lévy

Seated Woman (Paysanne assise dans l'herbe),
c. 1883
Oil on canvas, 38.1 x 46.2 cm
New York, The Solomon R. Guggenheim
Museum, Gift, Solomon R. Guggenheim, 1937

PAGE 18:
Rue St-Vincent, Montmartre, in Spring, c. 1884
Oil on panel, 24.8 x 15.4 cm
Cambridge, Fitzwilliam Museum

Bathers at Asnières

In the spring of 1883 Seurat started work on his first large-format painting, *Bathers at Asnières* (pp. 28/29). Measuring two metres by three in size, it is a composition in which the Impressionist motif of a bathing scene is expanded to a monumental scale. It portrays a popular bathing spot on the left bank of the Seine, above the two bridges that cross the river between Asnières and Clichy. Asnières itself was a suburb in north-eastern Paris where Seurat was fond of sketching and drawing; thanks to its new rail link, it was easily and quickly reached by train from the city centre. *Bathers at Asnières* shows men and youths bathing on the banks of the Seine, gazing across the river to the nearby island of La Grande Jatte (which was to be the subject of Seurat's next large-scale work). In the background are the modern bridges and the industrial zone which lay behind Clichy. Seurat eliminates neither from his composition, choosing not to paint a paradisiacal idyll of leisure such as we see in contemporary pictures by Monet and Auguste Renoir (1841–1919) with similar subjects. However, when Renoir portrays Parisians at leisure in his famous paintings *The Luncheon of the Boating Party* (p. 24) and *La Grenouillière* (p. 24), the effect is considerably more intimate and fresh than Seurat's distanced, almost indifferent depiction of bathing boys and men relaxing on the banks.

Seurat's figures are motionless, and the light and colours of the painting suggest the oppressive heat of a summer afternoon. Only the boats, the ferry and especially the cropped rower at the right edge convey any (albeit muted) sense of movement.

With its modern backdrop and even, bright light, Seurat's picture avoids any romanticizing view of its subject, but despite this the figures are memorable and dignified in their isolation. They are not prominent figures in society, nor indeed would we expect to find such figures here. In recent years, Asnières had evolved from a rural idyll into a dormitory town for a working population which commuted to the city centre. Within a short space of time, the number of the suburb's inhabitants had doubled. As for Clichy, it had become an industrial town, home to numerous factories and businesses.

To judge by their manner and clothing, such as the bowler hat of the man seen reclining in the foreground, the figures in *Bathers at Asnières* can be assumed to be members of the working class resident in the suburb. As can be seen in contemporary illustrations by Roger Jourdain (1845–1918; cf. p. 24), bathing at this spot was a pleasure of a rather rustic nature and served ordinary people as a welcome way of relaxing at the end of a day's work.

In contrast, the ferry crossing the river to the island of La Grande Jatte (p. 31) is full of passengers who clearly belong to a higher urban social class, such as

Study of a Bather, 1883–1884
Conté crayon, 31.2 x 24 cm
Private Collection

PAGE 20:
Bathers at Asnières (detail), 1883–1884
Oil on canvas, 201 x 300 cm
London, National Gallery

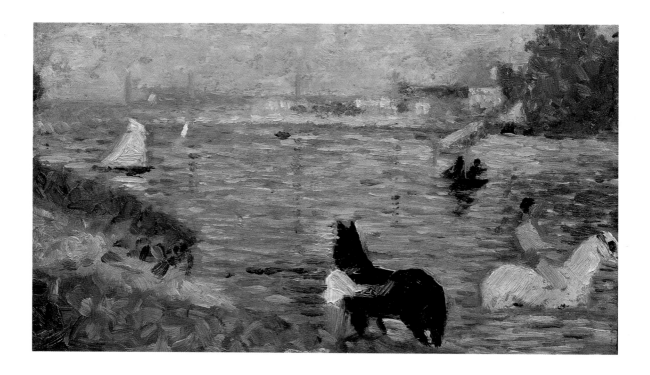

Horses in the Water, 1883
Oil on panel, 15.2 x 24.8 cm
Private Collection
On permanent loan to The Courtauld Gallery,
London

we find assembled on the complementary canvas *A Sunday on La Grande Jatte* (pp. 42/43).

It is striking that only men feature in *Bathers at Asnières*. The Académie des Sciences Morales et Politiques had declared in 1874 that the key to developing a moral code among the working classes was a Sunday day of rest, which working men would spend in the bosom of the family; but in fact working men long resisted the Sunday family idyll à la middle class, preferring to have their day off on the Monday and to spend it (as Roger Jourdain's pictures indicate; p. 24) together with their workmates. With the sole exception of a woman visible on the ferry, Seurat's painting shows only men.

Bathers at Asnières is the first painting by Seurat to be prepared in numerous studies and *croquetons*. Unlike the Impressionists, who were out to catch the fleeting moment and for that reason generally liked to work spontaneously in the open, Seurat prepared his works meticulously. He recorded the landscape and figures on the spot, working in oil on small wood panels. Parallel to these oil studies, he also made drawings of the same subjects in Conté crayon. Then, in his studio, he painted the final composition, uniting all the preliminary studies into a balanced whole.

The Impressionist style which Seurat had tested in earlier *croquetons* is particularly pronounced in *Horses in the Water* (p. 22), an oil sketch reminiscent of Renoir. The left half of the picture offers a spacious view across the water towards the industrial area lying beyond. In the foreground we see two horses which have been led down the riverbank to the water. A youth sits astride the white horse, riding in the water, while the black horse is being groomed on the bank. For all the painting's shimmering palette, however, the peopling of the scene is still clearly problematical.

Another *croqueton* (p. 23) served to prepare the left half of the subsequent picture, and shows a figure located hard against the edge. In the foreground on the right, a boy in a blue shirt is standing beside a black pony in the water. The seated man, and the man lying on his stomach in the background, were included in the final version. In contrast to the large painting, the palette of this sketch, with its rich, dark shades, tends rather to convey the feeling of a rainy day.

A further sketch shows Seurat testing the positioning of the figures in the landscape setting (p. 25). The acute foreshortening of the bathers in the water, when compared with the foreground figures, makes the considerable height of the embankment at the Asnières bathing spot particularly apparent. Seurat made a large number of naturalistic studies of individual components of what was to be the final painting. However, a monumental pictorial effect could not be achieved in sketches of this kind.

In addition to the *croquetons*, Seurat produced several drawings in order to work out the main figures in more detail. Here for the first time he attempts to achieve a synthesis of painting and drawing by means of chromatic transitions and pronounced aureoles around the figures (p. 26). The posture of the youth sitting on the left was analysed in such depth (p. 26) that Seurat was able to incorporate it into the painting without change. If the drawing and the final painting are compared, it is immediately apparent how Seurat has translated the chiaroscuro effects achieved with Conté crayon into the oil painting. There are also several drawings of the reclining man in the foreground (p. 33), each of which concentrates on specific details and develops them mainly in terms of the contrast of light and dark.

Study for "Une baignade", Le Cheval Noir,
1883
Oil on panel, 15.9 x 24.8 cm
Edinburgh, National Gallery of Scotland

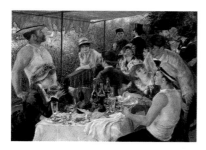

Pierre Auguste Renoir
The Luncheon of the Boating Party, 1881
Oil on canvas, 129.5 x 172.7 cm
Washington D.C., The Phillips Collection

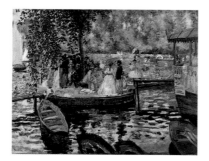

Pierre Auguste Renoir
La Grenouillière, 1869
Oil on canvas, 66.5 x 81 cm
Stockholm, National Museum

Roger Jourdain
Sunday on La Grande Jatte, 1878
Wood engraving of a painting whose whereabouts
are unknown from *L'Illustration*, 15 June 1878

Roger Jourdain
Monday on La Grande Jatte
Wood engraving of a painting whose
whereabouts are unknown
from *L'Illustration*, 15 June 1878

In the final version, our gaze is attracted by the individual figures to which particular emphasis is given, and led into the depths of the picture by the receding diagonal of the riverbank. Background and foreground fuse to establish both tension and unity. In contrast to Impressionist treatments of the same theme, the colours of Seurat's *Bathers at Asnières* are more muted, almost chalky – something due to the strong white highlights applied to the local colours, but with its origins, too, in the technique which Seurat adopted from Delacroix.

Seurat first applied an undertint or imprimatura, in the relevant local colours, over a pale-coloured ground. On top of this he then applied brushstrokes crosswise on top of each other, like a dense mesh. Seurat attached particular importance to the execution of the contrasts between light and dark, which strike luminous key notes throughout the picture. The surface of the water is either brighter or darker along the outlines of the figures standing in the water, making them appear more three-dimensional. This device, adopted from Chevreul, can already be seen in the drawings.

Seurat thereby avoids strong contrasts of colour. Only the tonal interplay of red/green and blue/orange is apparent, richly nuanced, throughout the painting, although it does not manifest itself in violent colour clashes as it might in the work of a van Gogh. Seurat even uses the earth pigments, ochres and browns long frowned upon by the Impressionists, and they lend the picture a soft, muted harmony. The delicate co-ordination of the local colours, the light palette and the placing of clear highlights appear to show the continuing influence of the Barbizon school.

The lightening throughout the picture also affects the shadows on the bodies, which are tempered to the adjacent level of brightness, becoming a violet grey, for example, alongside the yellowish flesh. The darker shadows on the ground are of well-defined form and emphasize the rhythm of the picture, as the body shapes themselves do.

Seurat thus orchestrates all the pictorial components, colours, forms and lines into a carefully balanced composition. The "sketchy" Impressionist effect has been transmuted into a depiction of great calm, harmony and well thought-out order.

The size of the painting, and its hieratic, almost classical composition, were not easy for Seurat's contemporaries to accept. *Bathers at Asnières* was rejected by the jury of the official Salon in 1884. And while the Societé des Artistes Indépendants, founded in protest against the Salon jury, did indeed exhibit Seurat's painting in its first major exhibition in the Paris Pavilion on the Champs-Elysées in December 1884, it hung it in the canteen, so strongly was it felt that the composition and motif were incompatible. This notwithstanding, the picture won the attention of fellow artists and critics alike. Thus Arsène Alexandre wrote: "The *Bathers* shows Seurat to be *the* artist of the young school, one of the few who understand how to compose a major work and use new techniques whilst doing so."

The isolated depiction of bathers is reminiscent of the allegorical tradition of the idyll and, above all, of contemporary works by Puvis de Chavannes, who had returned to this type of picture in his large murals. Amongst avant-garde painters, Puvis de Chavannes was considered to be the protagonist of a type of art which, in the wake of Impressionist exuberance, once again emphasized the order of composition.

Seurat copied another famous painting by Puvis, *The Poor Fisherman* (1881), incorporating Puvis' small easel painting into a landscape within his oil sketch *Hommage à Puvis*. Seurat thereby lent expression to his desire to combine

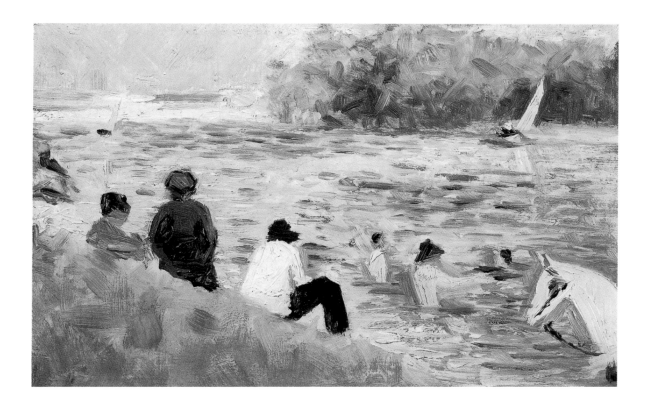

Bathers, 1883
Oil on panel, 15.25 x 24.5 cm
Upperville (VA), Collection of
Mr and Mrs Paul Mellon

Puvis' synthetic style with Impressionist *plein-air* painting. In 1888, the poet
and critic Gustave Kahn (1859–1936) wrote an article on Puvis de Chavannes in
which he stated that "one of the young Impressionist innovators"– by which he
meant Seurat – was attempting to depict modern man in the manner of Phidias'
Parthenon frieze. "As on this frieze, [Seurat aims] to present modern people in
their essential individuality and portray them in pictures in which the colour har-
monies, the gradation of the tones and the harmonies of the lines are orchestrat-
ed in accordance with the direction of the lines."

Only in Seurat's other major work, *A Sunday on La Grande Jatte* (pp. 42/43),
is the impression of a contemporary Arcadia created; despite the richness of its
light, however, it remains sober and unromantic.

Paul Signac, who was represented at the first exhibition of the Indépendants
in 1884 by some of his own Monet-inspired works, was one who noticed the
painting. Soon the two artists were exchanging views and stories and, above all,
their expectations and hopes relating to painting. Through Seurat, Signac be-
came familiar with Chevreul's laws of colour. Seurat in turn reworked some
sections of *Bathers at Asnières* on the advice of his new friend, differentiating
their colour values by applying his paint in dots.

Signac wanted to study the principles of colour contrasts in greater detail, to
which end he visited Chevreul. But the latter, now almost a full hundred years
old, was no longer capable of answering Signac's questions. All the painters
were able to do was continue studying academic works on colour theories
themselves. Apart from Chevreul's work, a particularly useful book was *Modern
Chromatics*, a study of colour theory written by the New York physicist and

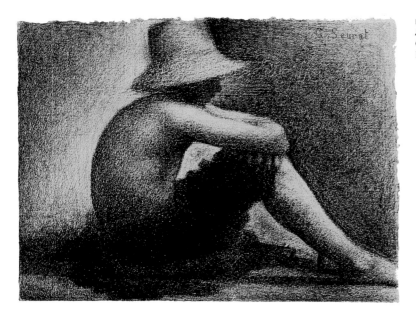

PAGE 27:
Seated, Nude, 1883–1884
Conté crayon, 31.7 x 24.7 cm
Edinburgh, National Gallery of Scotland

Boy with Straw Hat Seated on the Grass,
1883–1884
Conté crayon, 24 x 30 cm
New Haven (CT), Yale University Art Gallery

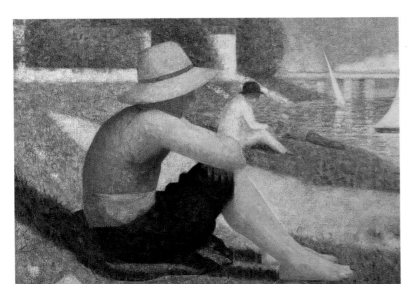

Bathers at Asnières (detail), 1883–1884
Oil on canvas, 201 x 300 cm
London, National Gallery

amateur painter Ogden Nicholas Rood (1831–1902) in 1878, which appeared in a French edition in 1881. From Chevreul and Rood Seurat learnt that colours reach the eye as light of different wavelengths, and are mixed on the retina. In due course this led him to a method of juxtaposing dabs of primary colour on his canvas rather than mixing his pigments on the palette.

A central aspect of Rood's research was the distinction between the additive mixture of light and the subtractive mixture of pigments, which at the time was

PAGES 28/29:
Bathers at Asnières, 1883–1884
Oil on canvas, 201 x 300 cm
London, National Gallery

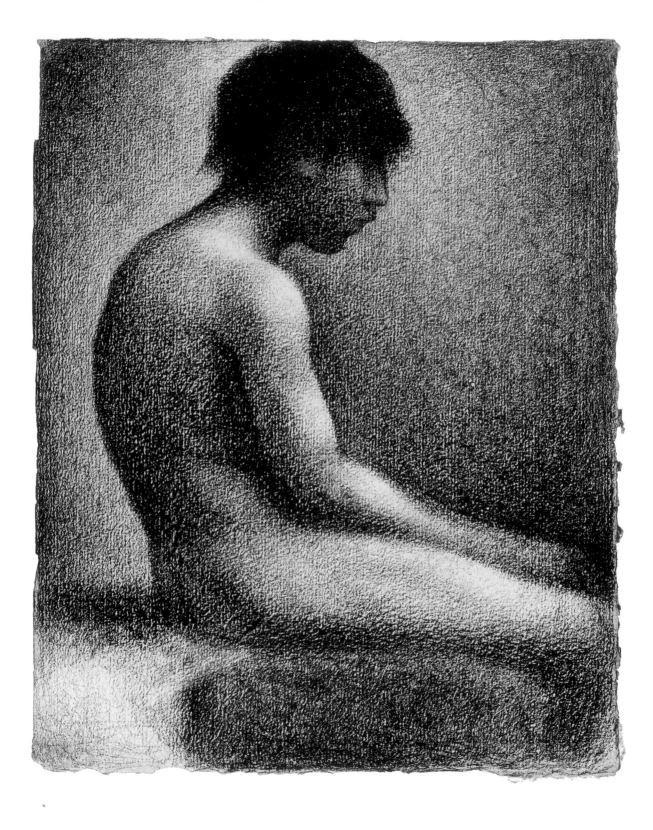

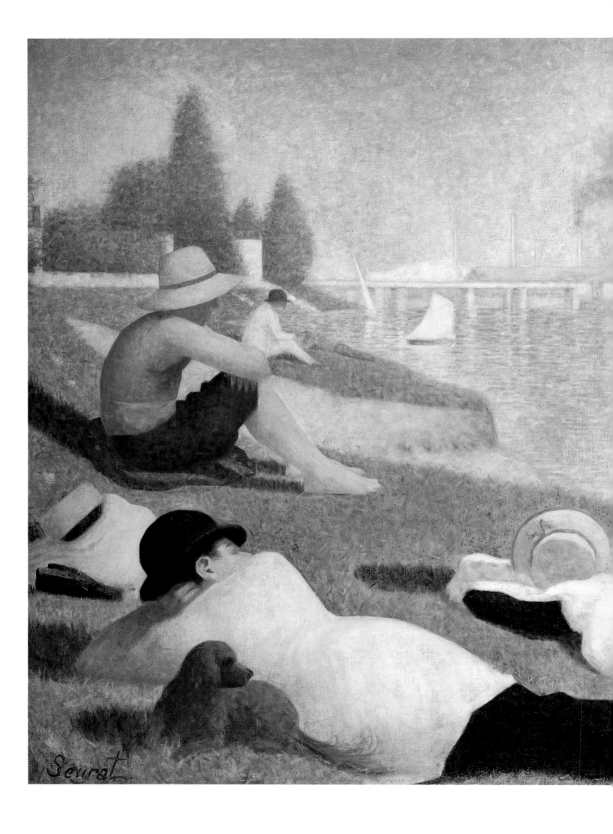

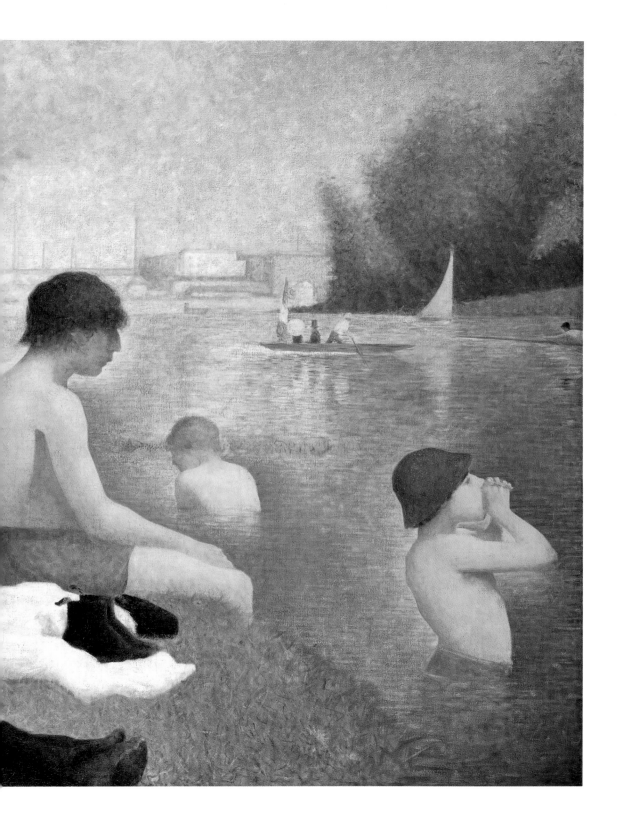

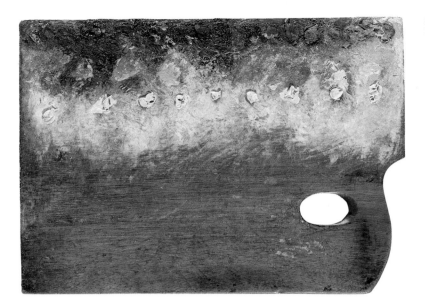

Seurat's palette, c. 1891
Paris, Musée d'Orsay

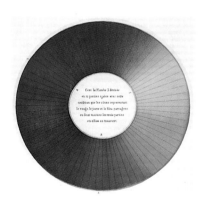

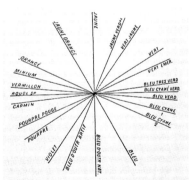

LEFT:
Michel Eugène Chevreul
Colour Circle, 1864
from M. E. Chevreul: *Des couleurs et de leurs
applications aux arts industriels. À l'aide de
cercles chromatiques*, Paris, 1864

RIGHT:
Ogden N. Rood
Diagram of Complementary Contrasts, 1881
From O. N. Rood, *Théorie scientifique des
couleurs et leurs applications à l'art et à
l'industrie*, Paris, 1881

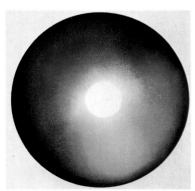

LEFT:
Charles Henry
Colour Circle, 1889
From C. Henry: *Cercle chromatique*, Paris, 1889

RIGHT:
Device for creating gyroscopic mixtures
(with Maxwell plates)
From I. W. Homer: *Seurat and the Science
of Painting*, Cambridge (Mass.), 1964

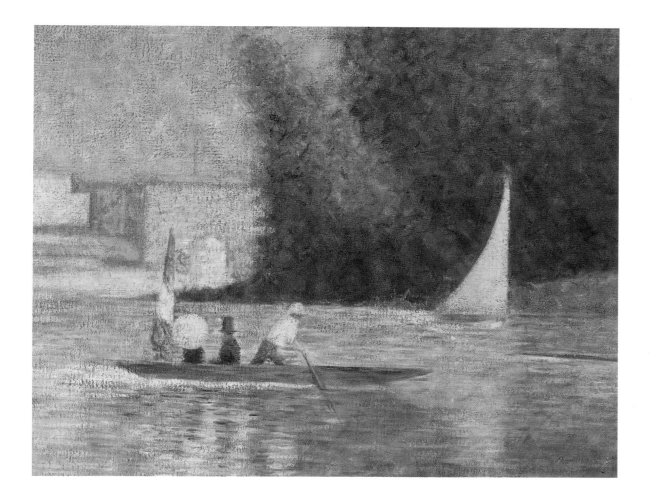

Bathers at Asnières (detail), 1883–1884
Oil on canvas, 201 x 300 cm
London, National Gallery

still little known. Rood based his theory on the most recent work on the physiology of the eye by Hermann Helmholtz (1821–1894) and on the undulatory theory of light outlined by the English physicist Thomas Young (1773–1829). On the basis of his own tests, Rood was able to confirm that red, yellow and blue were only primary colours where the subtractive mixture of colour pigments was concerned, while the primary colours of light were orange-red, green and violet-blue. To do this, Rood availed himself of a form of experiment that had been developed by the Scottish physicist James Clerk Maxwell (1831–1879; cf. p. 30). To make an additive mixture, the two colour pigments are applied next to each other on a round plate. If the plate is rotated rapidly, the resulting colour is similar to the mixed shade created by a subtractive mixture of the two pigments. Comparing them showed that the gyroscopic mixture (or speed mixture) was invariably more radiant than the pigment mixture. From this Rood concluded that painters should not mix their colours too much but should, whenever possible, juxtapose pure, unmixed pigments. Rood evolved numerous equations and technical processes for applying colour to attain this "optical mixture".

Of greater importance than this "optical mixture" was Rood's research into the field of what are termed complementary colours, that is to say, colour

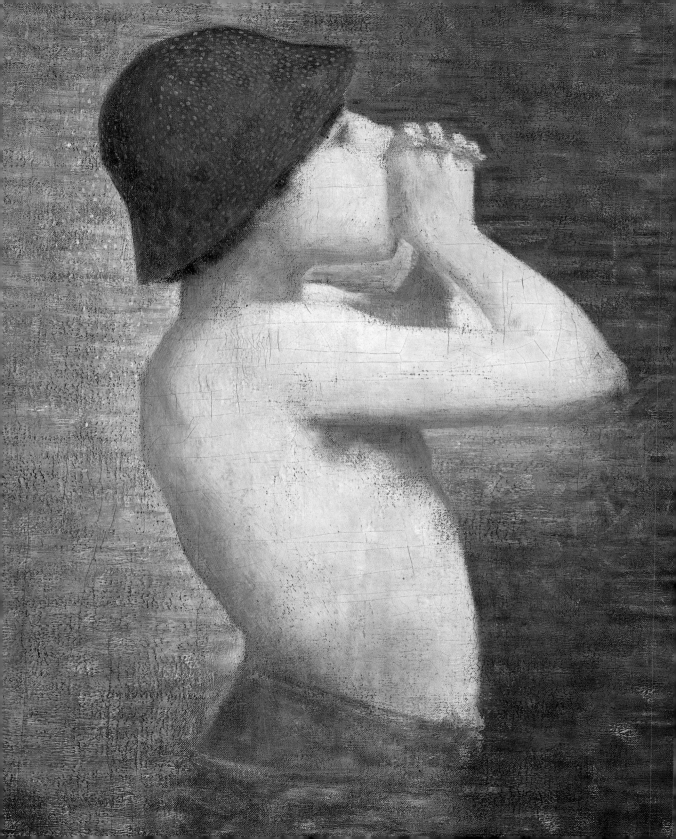

Man Reclining on the Grass, 1883–1884
Conté crayon on Ingres paper, 24 x 31 cm
Basle, Beyeler Collection

contrasts that complement each other in the eye, or evoke each other in turn, and can increase the effect of colour in a painting to the highest degree of luminosity. By conducting experiments using Maxwell plates, Rood was able to establish precisely the matching complementary colours and enter them in a colour circle as opposite shades. This colour circle, which Seurat copied from the French edition of Rood's book (p. 30), was particularly useful for scientifically-minded painters, as it differentiated the schematic subdivision found in Chevreul's work – green opposed to red, yellow to violet, blue to orange – to establish accurately defined pigment colours (Chevreul colour circle, p. 30).

These theories were discussed in a circle of painters to which Seurat was introduced by Signac. It included the Impressionists Armand Guillaumin (1841–1927) and Camille Pissarro together with the Symbolist authors Robert Caze (1853–1886) and Gustave Kahn. Hauled out of his isolation and confronted with new ideas, Seurat turned to his next major painting, *A Sunday on La Grande Jatte*, in which he was to create a new style and also to found an artistic movement, Neo-Impressionism.

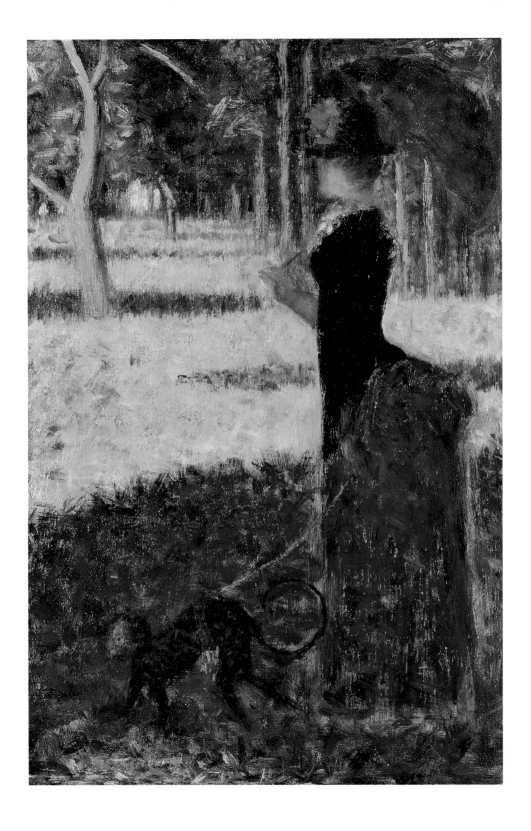

A Sunday on La Grande Jatte

Soon after completing *Bathers at Asnières*, Seurat was planning a second large-format painting. Towards the end of 1884 he embarked on studies of the landscape and figures in the park on the island of La Grande Jatte near Asnières. The island lies in the middle of the Seine, between Neuilly to the south-west and Asnières to the north-east. Its takes its name from its unusual shape, reminiscent of a classical dish (*La Grande Jatte*: the large bowl). Today it is a built-up tract of land, but in the 1880s La Grande Jatte was an idyllic recreational spot for the citizens of Paris. On Sundays in particular, the island was a very popular destination. All of Paris was out for a stroll amid the taverns and waffle bakers, or enjoying canoe trips, then in fashion. But La Grande Jatte was also a "modern Cythera", a love island for rendezvous between city men and loose women.

From a contemporary description of the painting, penned in 1890 by Jules Christophe (1840–1929), we learn that Seurat has included a broad cross-section of contemporary Parisian society: "On an afternoon beneath a blazing summer sky we see the Seine glittering in full daylight, smart villas on the opposite bank, steamers, sailing boats and a rowing boat gliding across the water. Close to us, beneath the trees, are people talking a walk, fishing, sitting on the lawn or stretching out on the cyanine blue grass. We see young girls, a nanny, an elderly grandmother beneath a parasol, exuding a Dantesque dignity from beneath her bonnet. Lolling in the grass and smoking his pipe is a canoeist, a brilliant shaft of light catching the lower leg of his pale trousers. A dark violet pug is sniffing in the grass, a chestnut butterfly flutters past, a young mother is holding the hand of her small daughter, clad in a white dress and a salmon-coloured belt. Two soldiers from the Saint-Cyr military academy are standing not far from the water's edge; a young girl has gathered a posy of flowers; a red-haired child in a blue dress is sitting on the grass. We see a married couple holding their baby in their arms, and on the extreme right of the picture, the hieratic and scandalous couple – a young dandy holding his arm out to his chi-chi companion, who has a purple-ultramarine monkey on a yellow lead."

What in Christophe's description appears to be a loosely Impressionist gathering of the Parisian middle classes is, however, strictly ordered in Seurat's painting (pp. 42/43). In order to emphasize the silhouette-like clarity of the individual figures, Seurat avoids virtually any overlappings. Despite the perspective depth of the composition, he thereby succeeds in emphasizing the surface of the picture, as in a frieze. With the exception of the girl skipping in the right half of the scene, the figures are all but motionless. What seems a fleeting moment captured on a Sunday afternoon is in fact isolated from time by the clear structuring of the composition. Seurat portrays the island in the suburbs as a modern

The Couple, 1884
Conté crayon, 30.1 x 23.8 cm
London, British Museum

PAGE 34:
Woman with a Monkey, 1884
Oil on panel, 24.8 x 15.9 cm
Northampton (MA), Smith College Museum
of Art, Purchased Tryon Fund, 1934

The Island of La Grande Jatte, 1884
Oil on canvas, 64.7 x 81.2 cm
Private Collection

Arcadia. There are neither bottles nor picnic hampers to be seen on the well-tended grass. Invisible, too, are the restaurants, cafés, boatyards and private residences which in the 1880s already occupied two thirds of the island. The visitors are taking a genteel stroll or relaxing in the shade. No one is bathing, no one has removed their clothing. These figures from everyday Parisian life appear to have been taken straight from Puvis de Chavannes' painting of *The Sacred Grove, Beloved of the Arts and Muses* (p. 38), which Seurat particularly admired. Seurat's figures, too, are strolling as if in a "sacred grove", removed from time and space. The painter tells no anecdotes; his protagonists have neither a face nor body language, neither a history nor individuality. The "modern people" whom Seurat declared he wanted to "portray … in their essence" are reduced to the formal attributes of top hat, cane and corset. The couple on the right, a Parisian citizen with a *demi-mondaine* and a monkey on a lead – a symbol of barely controlled drives – are a pointer to La Grande Jatte's popularity as an "island of love". The woman fishing on the far left of the picture is also an allusion to this theme. Fishing ladies (unaccompanied) were at the time considered to be "easy" women, as is also suggested by the similarity between the French words *pêcheuse*, meaning "fisherwoman", and *péché*, "sin", and *pêcher*, "to sin".

A light counterweight to the couple is the little girl dressed in white with her mother in the centre of the picture. Although there are white highlights distributed across the entire painting, in imitation of the Renaissance fresco technique, this section of the canvas particularly draws our eye, chiefly because the two figures are standing front on. The deliberate way in which they are placed in the centre of the picture suggests that they may harbour a symbolic meaning. The child could be interpreted as a symbol of hope, the principle of hope in a society that has become rigid to the point of being stereotyped. White also stands at the centre of all the colours: the prismatic colours are born of white light and can revert to white light. From his study of colour theories, Seurat was familiar with

Newton's experiment using a prism to split light into the seven colours of the spectrum. White was also at the centre of Rood's and Henry's colour circles (p. 30), which Seurat is proven to have used. It thus seems likely that colour theory represents an important key to understanding *La Grande Jatte*.

Once again, the composition was evolved using a series of preliminary studies which, in contrast to those for *Bathers at Asnières*, well-nigh defy arrangement in chronological order. Amongst the 34 painted and 28 drawn studies are sketch-like *croquetons* developing individual figural scenes, more detailed studies of the overall view with day-trippers (pp. 37, 39) and drawings of individual characters (pp. 35, 38). Seurat had already exhibited an oil painting of *La Grande Jatte* without figures at the 1884 Indépendants show (p. 36).

In the present work, Seurat again had to solve a problem similar to that in *Bathers at Asnières*. The banks of the island were so high that a true-to-life painting would be unable to incorporate both the visitors strolling on the island and the people sitting down by the water. The artist therefore extended our view of this part of the island by drawing the shoreline down on the left, enabling him to include the Seine; diagonal shadows of trees by the shoreline, clearly visible, are intended to indicate this declivity. There is no logical explanation, on the other hand, for the large shadow in the foreground. In a manner similar to Japanese colour woodcuts, which were also a valuable source of inspiration for the Impressionists, Seurat uses the two areas of shade at the top and bottom to direct our gaze to the middle of the picture. In the oil painting of the empty island (p. 36), reworked in the pointillist style, the abstraction from the original landscape is very apparent. Drawing on his sketchwork done on location, Seurat not

Oil sketch for ***La Grande Jatte***, 1884
Oil on panel, 15.5 x 25.1 cm
Chicago, The Art Institute of Chicago,
Gift of Mary and Leigh Block, 1981.15

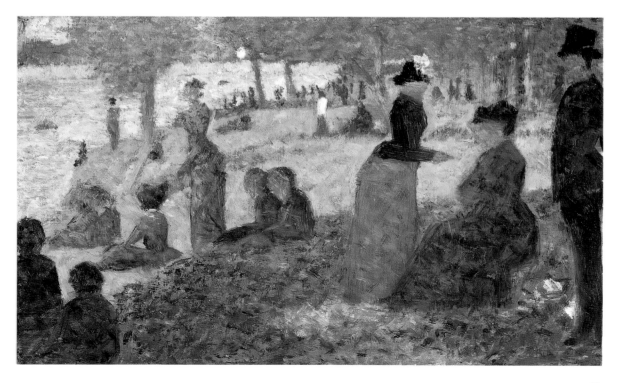

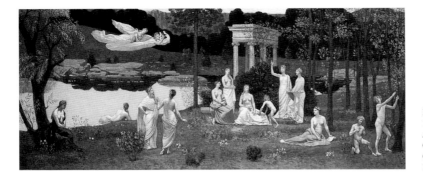

only evolved a strikingly planar composition, but also produced a stage on which the Parisian public could appear.

The wealth of figural studies, those made out of doors as well as others from models in his studio, clearly shows the difficulties with which Seurat contended when bringing his landscape to life. He created a repertoire of figures in a great number of individual studies, which he was then able to incorporate into the frieze-like composition of the painting. One of his earliest sketches (p. 37) still betrays his rather tentative search for a layout. The way the figures are gazing to the left does, however, appear to have been planned from the very start. The idea of a group of figures standing on the right as the point of entry was also adopted later in the final painting. The gentleman standing on the far right at the edge of the picture was moved, in another *croqueton*, further to the centre of the picture; in the finished painting, he plays the part of companion to the lady with the little monkey.

Seurat gave particular attention to this last figure in a number of studies and drawings. In one *croqueton* with a very Impressionist feel, the colours of the woman's clothes are already established, namely a violet skirt and black jacket (p. 34). The umbrella repeats the colours of the skirt, though in darker shades. She is already holding the lead of the tell-tale monkey, which is reduced in size to the point of caricature in the later painting, but which contemporaries unambiguously identified as the accessory of a *demi-mondaine*. Seurat also executed several drawings of the monkey in order to make sure of its anatomy and posture (p. 38). He studied the couple in their scenic surroundings in a large and lovely drawing in Conté crayon (p. 35).

The individual studies were then brought together in a final large study (p. 39). All the figures now appear in the places they will occupy in the final painting, with the exception of the two young women in the shade beneath the soldiers. Individual personae have been added: the man with the horn standing behind the elderly couple, the skipping girl and the two men in the foreground on the left. In comparison to the painting, the palette of this study is considerably more vivid. This is a result of the strong contrasts between light and dark, which were muted in the large painting in favour of a harmony of overall lighter colours.

The complementary contrasts, however, are not yet subtly differentiated. In the large painting a ruby red jacket contrasts with a blue skirt, a red-orange skirt with a blue jacket. According to Chevreul (colour circle, p. 30), the red-orange of the hat worn by the woman with the umbrella, the red of her jacket, the yellowish orange of the other woman's skirt, the yellowish brown of her hair and

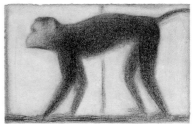

the reddish violet of the umbrella lying on the ground are all analogous colours. These warm colours contrast with the cold shades of the Prussian blue jacket of the girl with the flowers, the ultramarine skirt of the other woman and the hat lying on the grass. All the hues are nevertheless kept sufficiently dark so as to stand out clearly against the light green grass. As this example shows, Seurat modified the local colours of the studies which he made on location to correspond with his own colour theories.

In the final canvas, all the figures and their shadows appear to have been fully subjected to a thorough remodelling. Seurat thereby lends them a three-dimensionality new to the Impressionists. This he achieves both by giving the figures aureoles – a technique already employed in *Bathers at Asnières* – and via the carefully calculated contrast of light and dark between the figures and the background (details, pp. 44, 45).

This meant not only planning the entire layout in advance, but also establishing the sense of spatial depth it would create. Alongside the atmospheric perspective of the Impressionists, in *La Grande Jatte* Seurat also returns to linear perspective. He thereby used a geometric grid, based on a Pythagorean system of proportions as suggested by Blanc in his *Grammaire*, to help him organize and distribute the figures within the composition. The grid divides the composition into regular sections and determines the positions of the main personae in a manner which Blanc, following Pythagoras, called "the music of space".

After working on *La Grande Jatte* for two years, Seurat exhibited the painting, which measured more than two metres by three, at the eighth and final

Study for *A Sunday on La Grande Jatte*, 1884
Oil on canvas, 70.5 x 104.1 cm
New York, The Metropolitan Museum of Art
Bequest of Sam A. Lewisohn, 1951, (51.112.6)

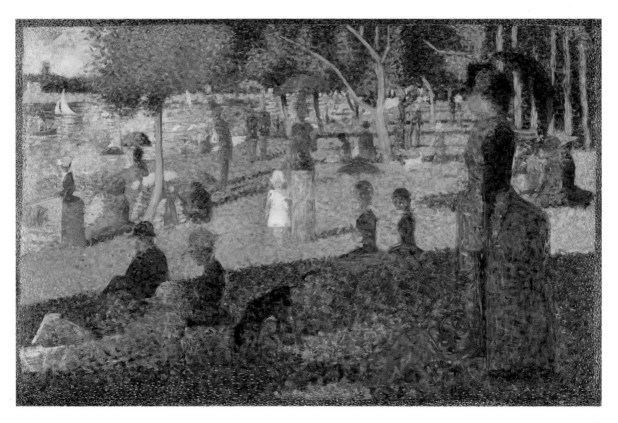

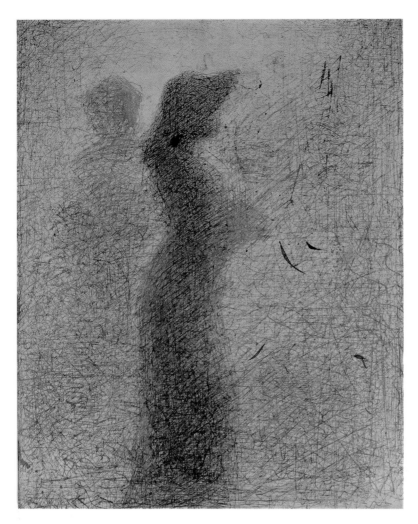

Walk, c. 1883
Pen and ink on paper, 29.8 x 22.4 cm
Wuppertal, Von der Heydt-Museum

Impressionist exhibition at the Maison Dorée in 1886. The picture was received in very different ways. Reactions varied from the bewildered to the incensed, much as they had at the first Impressionist exhibition, which had been the laughing-stock of the Parisian bourgeoisie twelve years before. There were also, however, serious critics who viewed Seurat's painting from quite different standpoints, as Paul Signac later recalled: "The two schools which were dominant at the time, the Naturalists and the Symbolists, judged it from their own points of view. J. K. Huysmans, Paul Alexis and Robert Caze saw in it the Sunday recreation of shop boys, butchers' assistants and women out for adventure. Paul Adam, in contrast, compared the stiff figures with the retinue of a pharaoh, and Jean Moréas, a native Greek, admired it as a Parthenon procession. However, all Seurat wanted to achieve was a clear, bright composition in which the vertical and horizontal lines were balanced, warm colours and light shades predominated and the most luminous white shone in the middle. Only the unerring Félix Fénéon produced an informed analysis of the painter's technical achievements."

PAGE 41:
The Hood, c. 1891
Conté crayon on Michallet paper mounted on card, 30.5 x 24 cm
Wuppertal, Von der Heydt-Museum

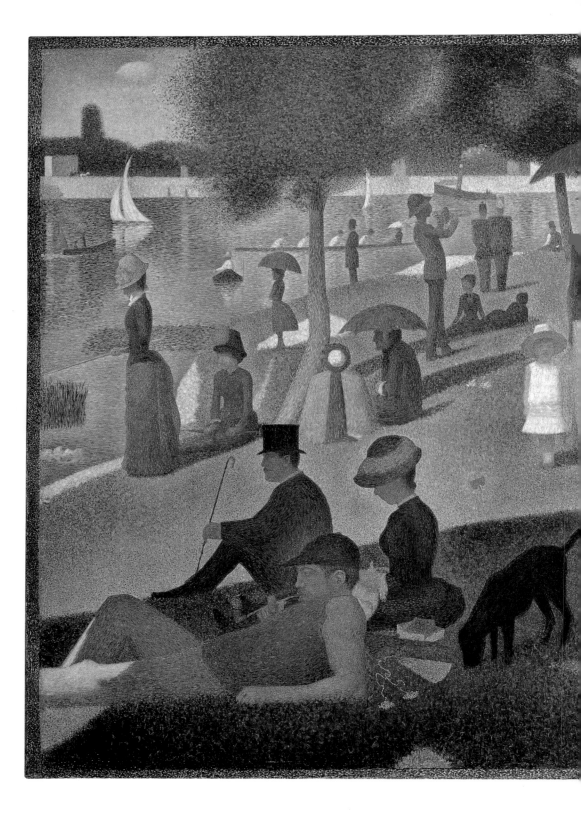

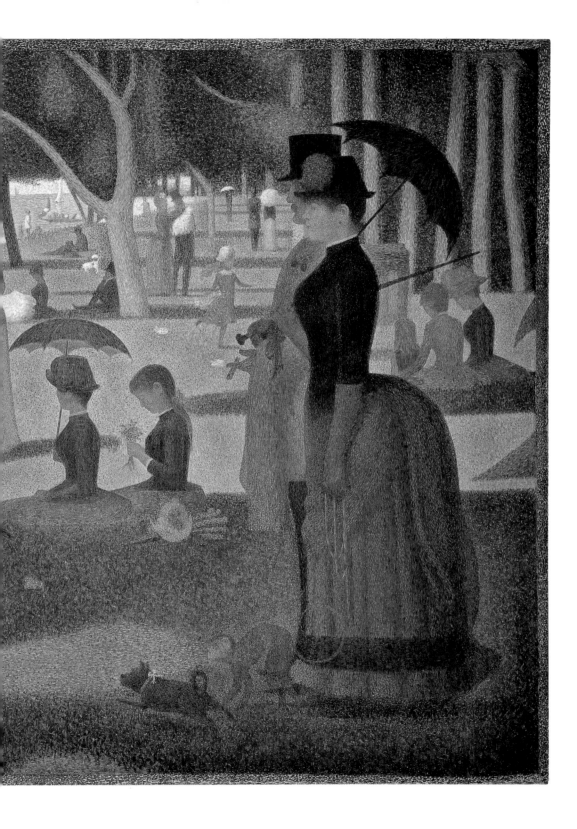

The journalist Félix Fénéon (1861–1944) was indeed the only critic who proved capable of articulating an appreciation of Seurat's picture, and the new method of painting it exemplified, in words notable for their objective tone. For it was precisely the picture's technique that aroused the most displeasure amongst the public, critics and artists. The American Impressionist Theodore Robinson (1852–1896) spoke contemptuously of men of little talent who with their paltry inventiveness had attached themselves to the Impressionist movement, in particular that genius who had thought up the style of fly droppings and dots. This outburst was prompted by the fact that Seurat, after a break in the summer of 1885 during which he had painted seascapes in Grandcamp, had reworked *La Grande Jatte* in a new technique using dots.

In the seascapes executed at Grandcamp, Seurat had tried out a refinement of his brushwork which resulted in paintings with an increasingly uniform paint structure. The most famous of these depicts the Bec du Hoc, a rocky outcrop to the east of Grandcamp, which Seurat painted towering as a solid shape, almost like a wave turned to stone, above the horizon of the calm ocean (p. 47).

Seurat adapted his composition from a well-known colour woodcut, *The Wave* (c. 1825–1830), by Katsushika Hokusai (1760–1849). The light grass-covered

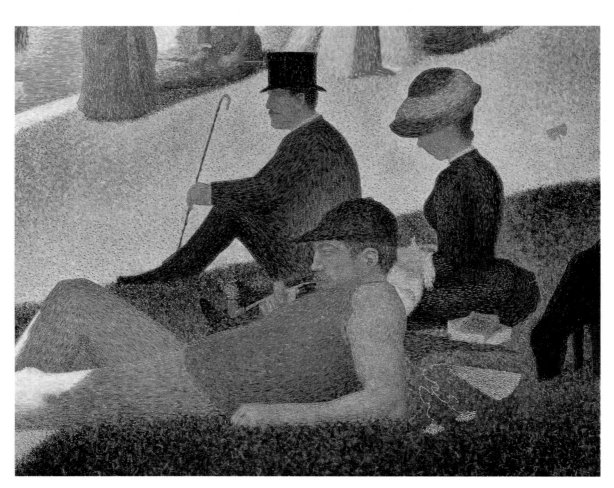

side of the rock is indeed lit up by the sun like a wave, and the yellow strips of sand look like white crests on the edge of the violet-shadowed cliff. Once again, Seurat emphasized the outline with an aureole which brightens the sea on the side toward the dark steep slope.

Seurat subsequently applied the technique which he had developed in Grandcamp to the already finished painting of *La Grande Jatte*. The characteristic features of this technique are perceptively elucidated by Fénéon:

"If one looks at any uniformly shaded area in Seurat's *Grande Jatte*, one can find on every centimetre of it a swirling swarm of small dots which contains all the elements which comprise the colour desired. Take that patch of lawn in the shade; most of the dots reflect the local colours of the grass, others, orange-coloured and much scarcer, express the barely perceptible influence of the sun; occasional purple dots establish the complementary colour of green; a cyanine blue, necessitated by an adjacent patch of lawn in full sunlight, becomes increasingly dense closer to the borderline, but beyond this line gradually loses in intensity … Juxtaposed on the canvas but yet distinct, the colours reunite on the retina: hence we have before us not a mixture of pigment colours but a mixture of variously coloured rays of light."

Seurat's method can now be described as follows: the painter separates the colour of an object into its local colour and the colour of light, taken to be orange, as can be seen from the dots of orange-yellow distributed throughout the painting. The other colours are derived from these two colours by applying the law of simultaneous contrast according to Chevreul: "Two bordering colours influence each other, each forcing its own complementary colour upon the other. Green will give rise to crimson in the bordering area, red to bluish green, yellow to ultramarine, violet to greenish yellow, orange to cyanine blue: a contrast of shades of colour. The lighter colour appears to be even lighter, the darker even darker: a contrast of degrees of brightness."

The orange of the light correspondingly establishes the blue in the shade, a red jacket requires a complementary bluish green, yellow gives rise to violet, and so forth. To these must be added the *irradiations* demanded by Chevreul's law, namely the "halations" induced when a light surface meets a dark one.

Thus the colours analysed by the artist and the changes in an object's colour as precipitated by the light are broken down into individual dots, to be reunited in glorious colour as an "optical mixture" in the eye. Seurat's assumption was based on Rood's experiments with Maxwell plates in which he attempted to elucidate the advantages of additive (light) mixture as opposed to subtractive pigment mixture. The rapid movement of the rotating plates, causing the eye to merge the impressions of light, cannot, however, be compared with the effect registered by the eye in moving, say, from a green to a red surface. For this reason, no optical mixture can take place in the picture.

The rationalization of colour started right on the palette, once a highly subjective instrument that told one much about the temperament of a painter. Seurat's palette has survived (p. 30): in the first row are eleven pure colours, with the earth colours missing, including mixtures of these colours with white, and in the last row are dots of pure white. Only adjacent (analogous) colours could be mixed, not complementary ones, as this would have destroyed the vibrancy of the hues.

The fine dots of colour on Seurat's painting, frequently mixed with white, do indeed merge together when viewed from a distance, however, and then appear as a veil of grey across the picture. Pointillism is only genuinely effective when

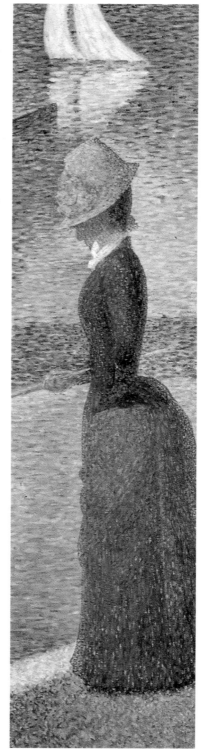

we alternate close-up and distant viewing to create a type of vibration or undulation in the colours, such as Blanc described in Delacroix' works and to which Rood assigned the term "lustre".

This elaborate painting technique was intended to let more light into the picture and offer a scientifically-based response to the Impressionists' spontaneous approach to painting. However, the sole advantage of this complicated analytical manner lay in its fine distinctions of colour; indeed, it was as if a veil of colour were being drawn over the things of this world. Seurat was mistaken about the importance of optical mixture for the impact of a picture, and in addition he started from incorrect assumptions about experimental psychology. For the vivid effect of a complementary arrangement of colour is created mainly by the effect of simultaneous contrasts brought about by the individual stimuli of colour.

Nonetheless, in addition to Fénéon there were some painters who were so convinced by this technique that they adopted "pointillism" and applied it to every conceivable subject. One particular champion was Signac, who got on very well with Seurat and was adept at expressing many of his rather confused-sounding theories more clearly. Camille Pissarro also possessed this gift, and after initial scepticism he became an enthusiastic advocate of what Fénéon had dubbed Neo-Impressionism, interpreting the complicated colour theories in his own way. His eldest son Lucien Pissarro (1863–1944) also became a talented pointillist. In 1886, Albert Dubois-Pillet (1846–1890) and E. G. Cavallo-Peduzzi (1851–1918) joined the group, while Maximilien Luce (1858–1941), Louis Hayet (1864–1940) and Charles Angrand (1854–1926) exhibited their first pointillist paintings in 1887.

The Belgian poet Émile Verhaeren admired *La Grande Jatte* so much that he introduced Seurat to his friends, the painter Theo van Rysselberghe (1862–1926) and the lawyer and art critic Octave Maus (1856–1919), who were the intellectual leaders of a number of avant-garde artists who had joined to form the Brussels group "Les Vingt" (The Twenty). Seurat was invited to

The English Channel at Grandcamp (La Manche à Grandcamp), 1885
Oil on canvas, 66.2 x 82.4 cm
New York, The Museum of Modern Art
Estate of John Hay Whitney

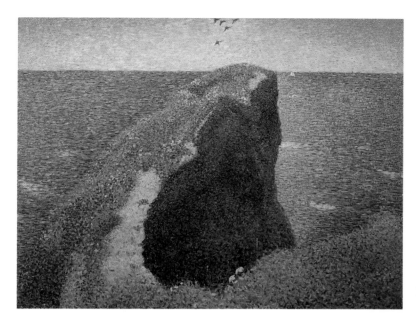

Le Bec du Hoc, 1885
Oil on canvas, 64.8 x 81.6 cm
London, The Tate Gallery

show *La Grande Jatte* once more at their spring exhibition of 1887, and this in turn created a new circle of pointillists in Belgium. Seurat's influence was also gradually growing in Paris. In the 1886 summer exhibition of the Indépendants, he once again exhibited *La Grande Jatte* together with seascapes from Grandcamp and Honfleur.

Two views of the Seine clearly show how confident Seurat was in his use of the new technique. *The Bridge at Courbevoie* (p. 49) depicts an overcast day on the Seine, the atmosphere of which is reproduced in a marvellous colour harmony and the finest pointillist technique. The composition of vertical and horizontal lines establishes a rhythm that acts as a counterpoint to the shimmering cascade of dots. The motif of the second painting, *The Seine at La Grande Jatte, Spring* (p. 48), harks back to the large *Grande Jatte*. Without repeating the austerity of the masterpiece, Seurat manages to convey the impression of a sunlit, warm spring day in sheer visual poetry, using a less systematic, more relaxed application of colour.

La Grande Jatte had made Seurat the focus of the avant-garde almost overnight. At a time when two systems of philosophy, those of materialist Positivism and mystical Symbolism, were almost irreconcilably opposed to each other, one probable reason why Seurat's painting attracted so much attention was that it was (and still is) open to many interpretations. If *La Grande Jatte* is considered as a pendant to *Bathers at Asnières*, as Seurat apparently intended, the two paintings can certainly be interpreted as studies of society, modern history paintings which, by uniting different contemporary walks of life, depict an affectionately ironic cross-section of Parisian society in about 1886. This interpretation would explain Seurat's comment to Gustave Kahn, to the effect that he aimed to present people in their essential individuality, as on the Parthenon frieze. Seurat planned to create a large panorama of his age in which light and shade, poor and rich, good and evil would be united in a large composition governed by the latest insights of science.

The Seine at La Grande Jatte, Spring, c. 1887
Oil on canvas, 65 x 81 cm
Brussels, Musées Royaux des Beaux-Arts
de Belgique

Whether the enigmatically inflexible picture is judged, in a reversal of Bloch's "principle of hope", to be an "anti-Utopian allegory" (Linda Nochlin) critical of society, or, in more unbiased vein (and more naturalistically), as "a procession of contemporary society" (Kahn), whether it is seen as the near-perfect application of the laws of colour theory (Fénéon) or as a return to classical composition (Moréas), will continue to depend on one's personal point of view. Whichever position we adopt, *A Sunday on La Grande Jatte* will always remain what it was for Seurat's advocates: at once a technical and an intellectual masterpiece.

Despite the painting's *succès de scandale*, and although the artist's mother would gladly have consigned it to a museum, *La Grande Jatte* long remained in the possession of Seurat's family. Nine years after Seurat's death, Signac took the matter in hand and had the huge painting put up for sale at a private auction of the artist's works. Seurat's drawings were priced at 10 francs unframed, or 100 francs framed. *La Grande Jatte* went to a well-to-do Parisian for a mere 800 francs. The painting was subsequently offered to the Metropolitan Museum in New York, but the acquisitions committee refused to approve its purchase. The Chicago collector Frederic Clay Bartlett displayed more acumen and initiative when in 1924 he bought the painting in Paris for $20,000. Not long

afterwards he donated the picture to the Art Institute of Chicago, where it is housed today as a key work of modern European art. In 1931 a French consortium offered the handsome sum of $400,000 to buy it back, but without success.

The Bridge at Courbevoie, c. 1887
Oil on canvas, 46.4 x 55.3 cm
London, Courtauld Gallery

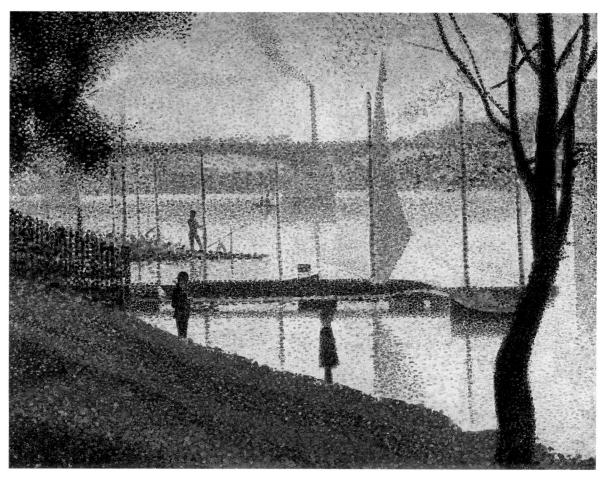

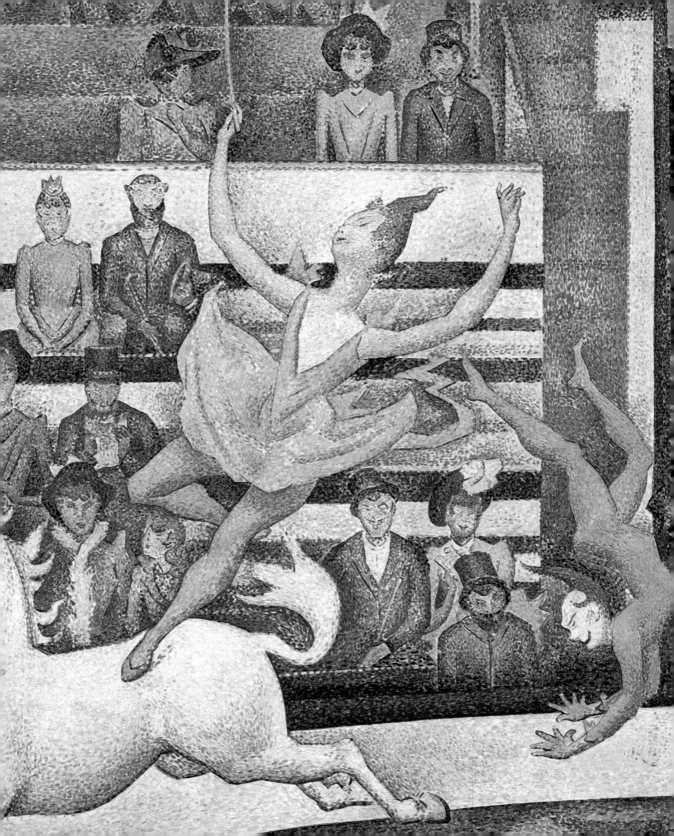

Parisian Life: Nudes, Vaudeville and the Circus

Seurat had not only become well-known with *La Grande Jatte*, he had also come under fire from the critics. While some artists considered the rigid system of pointillism to be a way out of the dead end of Impressionist bravura, and started employing it in their work, others reviled it and complained to Seurat that his new technique could only be applied to landscapes. Criticism was principally aimed at the stiffness of the figures in *La Grande Jatte*, which many took not as the intended style of the artist, but as a consequence of his lack of technical ability. Soon afterwards Seurat riposted with *Les Poseuses* (The Models; pp. 52, 53), a large picture including figures in which the familiar classical theme of the Three Graces was given a new and unusual interpretation.

This painting was once again preceded by studies, sketches and drawings. The individual models are depicted on three panels (pp. 54, 55, 69), and one study concentrates on the overall composition. While the painting itself was given a somewhat wary reception, the studies for it have always been considered masterpieces. The finely-dotted, small-format *croquetons* emanate a charm and grace that some critics at the time even compared with Ingres. Seurat had indeed studied Ingres during his time at the Academy, and was also trained in the academic manner of life drawing. Sharp observers were quick to notice similarities between *Les Poseuses* and paintings by Ingres, such as the famous *Baigneuse de Valpinçon* (1808; Paris, Musée du Louvre) or *The Spring* (1856; Paris, Musée d'Orsay). Within the Academy tradition, the subject of the Three Graces – the Greek version of which had just become part of the Louvre collection – provided an opportunity to display one's talents as a draughtsman.

Depictions of bathers, nymphs, Arcadia, the seasons and other female allegorical figures were consequently extremely popular in the Salon painting of the 1880s. Even painters of the avant-garde, such as Cézanne and Renoir, had turned to this theme, deliberately attempting to revive the academic tradition of figural composition. But while nudes in their paintings are depicted in a landscape, in his picture Seurat forgoes any idyllic setting and places the models, bereft of any erotic charisma, in a prosaic studio situation. In accordance with academic convention, Seurat shows us one nude from behind, one standing, and one seated and seen from the side. The youthful models appear to be absorbed, almost lost in themselves, in a space which is identified as Seurat's studio by the presence of *La Grande Jatte* hanging on the wall. Was Seurat, in contrasting clothed and naked figures, attempting to show the critics that his style could also be applied to paintings of nudes?

The technique of *Les Poseuses* is even more subtle and in all yields a more naturalistic effect than that of *La Grande Jatte*. But this very refinement was

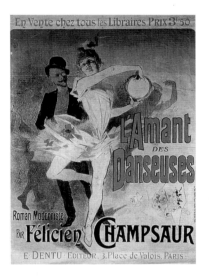

Jules Chéret
Poster advertising a novel by Félicien Champsaur, "The Dancers' Lover", 1886
Colour lithograph

PAGE 50:
The Circus (detail), 1890–1891
Oil on canvas, 185.5 x 152.5 cm
Paris, Musée d'Orsay

Standing Model, c. 1887
Ink drawing, 26.4 x 16.1 cm
Washington D.C., National Gallery
The Armand Hammer Collection

criticised by some on the grounds that it focused one's attention too much on the painting technique. It was perhaps in response to these complaints that Seurat painted a second version of the composition, in which his deploys pointillism in a more relaxed fashion and with a greater intensity of colour (ill. below).

The artist was not, however, merely interested in refining his pointillist method. The contrast between *La Grande Jatte* and *Les Poseuses* was also intended to prove to his critics that the differences in their execution were not a consequence simply of his personal artistic development, but were first and foremost a question of style. Seurat had already tried out the models' poses and the effect of the colours in the *croquetons*. In contrast to *La Grande Jatte*, the colours in *Les Poseuses* are opaque and broken down into a multitude of nuances which from a distance give the picture the grey veil complained about by Signac. The aureole effect is also considerably refined. In addition to the lightening or darkening around the contours, in the standing model in the second version, for instance, there is also a second aureole in the complementary colours (ill. below).

The painted frame of the study is an innovation which it shared with the large painting, though the latter's frame was unfortunately destroyed at a later date. Previously, in *La Grande Jatte*, Seurat had adopted the white frame with which the Impressionists had replaced the conventionally gilt frames seen in the Salon. Even this, however, did not satisfy the requirements of the Neo-Impressionists. In the case of the first version of *Les Poseuses* now in the Barnes Foundation in Pennsylvania (p. 53), Seurat painted the white frame in colours complementary to those in the picture, albeit in a fashion still somewhat incomplete compared with his later paintings. He also introduced painted borders into the study of the *Seated Model, Side View* (p. 54) and the study of the overall composition; these would become a feature of all his large paintings from now on. They convey a suggestion that the frame in fact begins on the canvas itself, in the border surrounding the central motif.

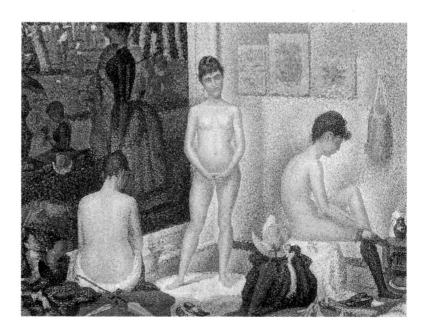

Les Poseuses (2nd version), 1888
Oil on canvas, 39.5 x 49 cm
Private Collection

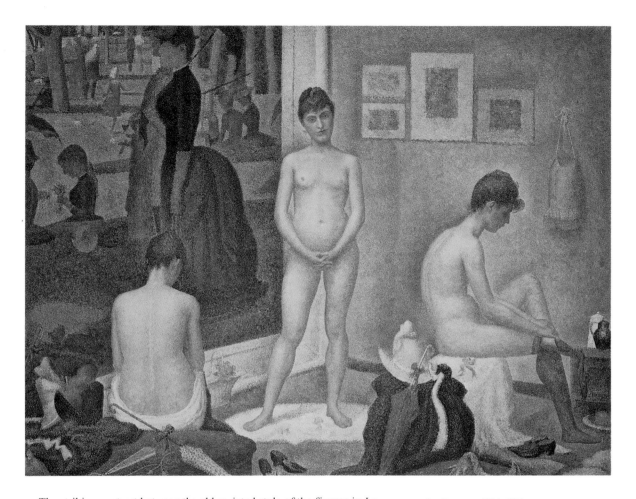

The striking contrast between the abbreviated style of the figures in *La Grande Jatte* (pp. 42/43) and the softly flowing contours of *Les Poseuses* (p. 53) is echoed in the different composition of the two paintings. In *La Grande Jatte*, spatial depth is conveyed by pictorial planes staggered one behind the other in the manner of a relief. In *Les Poseuses*, the nude figures are presented within a spatial box whose front edge is hidden from view. If we compare the size of the three figures, it is noticeable that they do not relate to one another according to the laws of perspective, but have been assigned their places so as to anchor Seurat's vision of his pictorial space. The objects lying on the floor of the studio similarly serve to define the interior and, through their diagonal arrangement, open up the pictorial space further.

The smaller, later version of *Les Poseuses* (p. 52) is altogether more colourful. The dots are larger and placed more unevenly, producing an impression of greater vividness and realism than the first version. This second version was underpainted in ochre before the pointillist layer was added. Dots of varying sizes were applied to this uniform surface of colour, which is much like the wooden ground of the *croquetons*. The palette is dominated by red-violet, which unifies the tonality of the painting and is particularly present in the background. Seurat was evidently using this hue to convey the shadowy light in the studio.

Les Poseuses, 1886–1888
Oil on canvas, 200 x 250 cm
Merion (PA), The Barnes Foundation

PAGE 54:
Seated Model, Side View, c. 1887
Oil on panel, 25 x 16 cm
Paris, Musée d'Orsay

PAGE 55:
Model, Rear View, 1887
Oil on panel, 24.5 x 15.5 cm
Paris, Musée d'Orsay

It provides a complementary balance to the orange and yellow dabs making up the models' bodies. The meticulously worked contrasts in the background are accentuated by the intense colourfulness of the objects lined up at the front edge of the picture, whereby the figures, depicted in more muted colours, recede into the depths.

Only once did Seurat try his hand at a large portrait. *Young Woman Powdering Herself* (p. 57) depicts his lover Madeleine Knobloch, whom Seurat met in the spring of 1889. Although the portrait was painted in the same meticulous pointillist manner as *Les Poseuses*, the sitter – laced into a tight corset and armed with a powder puff – seems an affectionate caricature of a woman who has ended up in surroundings and a society foreign to her. This impression is heightened by the dainty little rococo dressing table and the open picture frame, which was originally to have contained Seurat's self-portrait; this was replaced by flowers in a vase on the advice of a friend. The entire painting is infused with swirling spirals of colour, which together with the buttercup pattern in the wallpaper create an impression of movement. The spirals show the influence of the theories of a young scientist named Charles Henry (1860–1887), according to whom rotation from left to right expresses pleasure. The colours of the painting contribute to this impression as well. The woman's flesh, her skirt, the flowers and the powder puff are in red and yellow, with white highlights and blue shading. In contrast to these is the cyanine blue of the background. The same pair of complementary colours is repeated, somewhat darker, in the blue-violet corset and the little golden-brown table. At the top the picture ends in a shallow arch which, according to Seurat's aesthetic theories, was intended to counterbalance the rising lines.

It was surely far from Seurat's intention to make fun of his mistress in this large portrait, which he exhibited in Paris in 1890. With gentle irony, however, he points to the middle-class constraints on women at the time, and to the gulf between socially dictated vanity and natural beauty, which may also be symbolized in the flowers.

While Seurat worked on seascapes during the summer, he spent the winter months working on demanding *toiles de lutte*, "campaign pictures" in which he invested all his ambition. In addition to *Les Poseuses*, he created another brilliant work, *Invitation to the Sideshow*. Both paintings were exhibited at the Salon des Indépendants in March 1888.

Invitation to the Sideshow (pp. 60/61) is Seurat's most mysterious and darkest painting, not merely on account of its artificial lighting, which provided the artist with a welcome opportunity to include the complementary aureoles that are a phenomenon of gaslighting.

The scene unfolds against the backdrop of the Cirque Corvi, which had been performing since April 1887 on the Gingerbread Market (foire au pain d'épice) in the Bois de Vincennes, near the Place de la Nation. Seurat, himself a regular visitor to the circus and other places of entertainment, portrays the ringmaster in the process of announcing the circus programme. He is accompanied by a brass band lined up behind a music stand, and a trombonist, dressed as a clown, standing on a platform. At the lower edge of the picture the audience are waiting for admission, and some of them are already climbing the steps on the right to the box office.

In deliberate contrast to the naturalistic style of *Les Poseuses*, Seurat has here opted for an extremely rigorous composition. This is evident not only in the frieze-like alignment of the figures, but also in numerous formal relationships

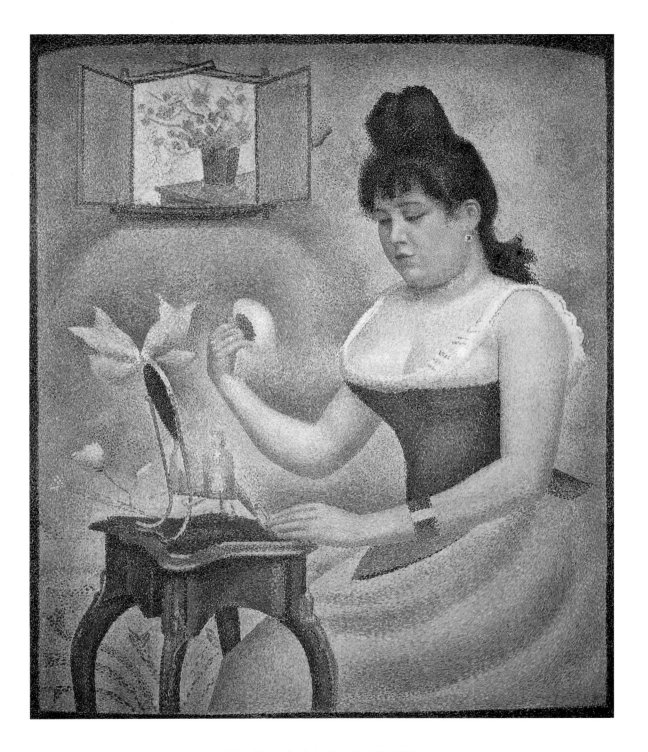

Young Woman Powdering Herself, c. 1888–1890
Oil on canvas, 95.5 x 79.5 cm
London, Courtauld Gallery

within the painting: the music stand, for example, finishes at the lower edge of the trombonist's jacket, and the balustrade at his knees. The box office windows are evenly subdivided with a gaslight in the middle of each pane.

The figure between the ringmaster and the trombonist in the centre alerts us to Seurat's use, in this painting, of the golden section. In mathematics, the golden section is the term for the division of a straight line into two parts of unequal length. The ratio of the smaller to the larger part is the same as that of the larger to the whole. This canon of proportion had been deployed in the visual arts since antiquity, in the conviction that the universe was founded on structural principles capable of mathematical articulation. In painting and architecture, the use of the golden section for proportional relations was intended to express universal harmonies.

In *Invitation to the Sideshow*, numerous lines can be identified which divide the painting in accordance with this classical ratio (3:5, 5:8, 8:13, 13:21 etc.), such as the horizontal line through the music stand. If we subtract the height of the gaslights from the height of the picture, then the ratio of height to width is also in keeping with the golden section. The pictorial surface is rhythmically punctuated by a rigid arrangement of emphatically two-dimensional planes. Depth is indicated only by relief-like stacking of these planes and by contrasts of light and dark. Seurat had already to some extent applied this "Egyptian style", as his contemporaries called it, to *La Grande Jatte*, though in a less radical fashion.

This strict composition was once again executed after a series of preliminary studies and drawings. Seurat started by sketching the circus people in evocative chalk drawings, of which the study of the *Trombone Player* (p. 59) is one of the most beautiful. While this study is still executed in Seurat's familiar grainy, flat

Study for *Invitation to the Sideshow*, 1887–1888
Oil on panel, 16 x 26 cm
Zurich, Foundation Collection E. G. Bührle

style, a study of the overall composition is treated in his pointillist manner. Seurat only rarely applied the pointillist technique to his drawings, however. Here, the flat application of Conté crayon was more effective. An oil study for *Invitation to the Sideshow* (p. 58) evinces some lightly sketched colour values on an ochre-coloured ground.

The palette of the painting, like the composition, is also carefully constructed. The gaslighting provides the artist with the opportunity to create a diffuse luminosity in which the local colours are muted and the fine dots convey an atmosphere filled with light. The colours of the painting alternate mainly from violet to greenish yellow and from orange to blue. Their complementary contrasts are largely obstructed, however, by the fine distribution of dots, which instead creates a grey-coloured atmosphere that convincingly conveys the impression of a winter evening. Seurat heightens this sense of evening by applying, for the first time, certain formal principles which he had adopted from Charles Henry.

Henry, a friend of Gustave Kahn and Jules Laforgue (1859–1926), had published a treatise on scientific aesthetics (*Esthéthique scientifique*) in 1885 in which he sought to deduce a general formula of harmony from a combination of mathematical, physiological and aesthetic laws. Seurat became acquainted with Henry through Felix Fénéon, and regularly attended his lectures at the Sorbonne. Henry's theories were received with great interest towards the end of the 1880s, in particular by artists, and must have fascinated Seurat in his search for compositional laws.

A fundamental principle of Henry's teachings was the reduction of sensations to joy and pain, and their reinterpretation as "dynamogeny" (derived from *dynamogen*, the driving force) and "inhibition" (the retarding principle). From this he developed the theory of the symbolism of directions or lines, according to which lines moving upwards or from right to left are "dynamogenic" and express joy, whereas pain and grief are associated with movements downwards or from left to right. Particular chromatic hues correspond to this. Red and yellow together with their mixtures are considered to be stimulating or "dynamogenic", while cold colours such as green, violet and blue have an "inhibitory" effect. Henry represented these relationships in a circle diagram, in which stimulating colours correspond with stimulating directions, and inhibitory colours with inhibitory directions, due allowance being made for the laws of colour contrasts and the wavelengths of the various colours (p. 30). As the most "dynamogenic" colour, red appears at the top with bluish-green opposite it as its "inhibitory" complementary. The symbolism of the lines is applied to the circle in a corresponding fashion.

Seurat had already become familiar with a comparable theory through Blanc, namely the theory of the abstract expressive content of line, formulated in 1827 by Humbert de Superville (1770–1849). Here the meaning of the lines is derived from human facial expressions, with lines pointing downwards expressing grief and pain, and lines pointing upwards indicating joy and hope (p. 67).

In his *Aesthetics* Seurat summarized these theories in a simplified manner, mentioning Superville but not Henry. Seurat felt that the excessive influence of the scientist on artistic circles threatened his own pioneering role in the invention of pointillism. Thus he attempted to emphasize his own authorship by putting forward a theory of art that drew on a variety of sources. These range from theories of colour and form according to Chevreul, Rood, Helmholtz, Henry and Superville right up to optical mixtures.

The Trombone Player, study for
La Parade, 1887–1888
Conté crayon, 30.8 x 22.5 cm
Philadelphia, The Philadelphia Museum of Art
The Henry P. McIlhenny Collection

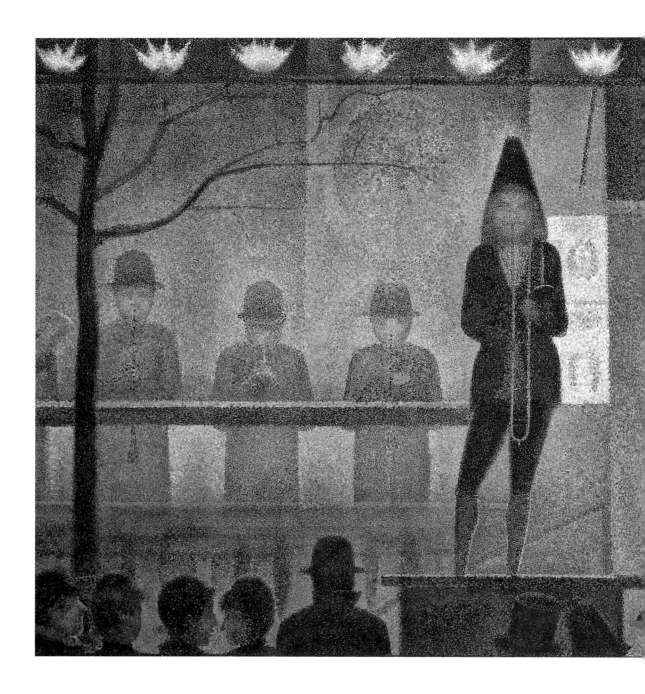

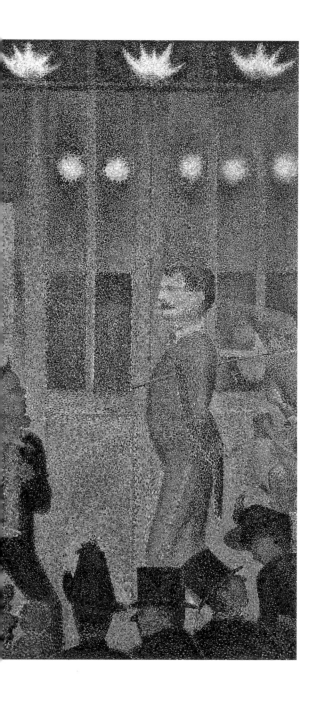

Invitation to the Sideshow (La Parade de Cirque), 1888
Oil on canvas, 99.7 x 149.9 cm
New York, The Metropolitan Museum of Art
Bequest of Stephen C. Clark, 1960, (61.101.17)

In a letter to Maurice Beaubourg of 28 August 1890, Seurat set out some of his ideas:

"Art is harmony. Harmony is the analogy of contrasting and similar elements, of tone, colour and line which, in accordance with their dominant and the influence of the light, can produce cheerful, peaceful or sad compositions.

The contrasts are:

For tonal value, a bright, light one as opposed to a darker one.

For colour, the complementary colours, i. e. a certain red is contrasted with its complementary colour etc. (red-green; orange-blue; yellow-violet).

For line, those which form a right angle.

Cheerfulness in tonal value is produced by a bright dominant; cheerfulness in colour by a warm dominant; cheerfulness in line by lines above the horizon.

Peacefulness in tonal value is produced by a balance of light and dark; peacefulness in colour by a balance of warm and cold; and peacefulness in line by horizontal lines.

Sadness in tonal value is produced by a predominance of dark, sadness in colour by a cold dominant and sadness in line by directions pointing downwards.

If one takes the phenomena of the duration of the impression of light on the retina as given, the result is a synthesis. The means of expression is the optical mixture of the tonal and colour values (the local colour and the colour of the respective light: sun, paraffin lamp, oil lamp, gaslight etc.), i. e. of the light and its effects (shadows) in accordance with the laws of contrast for toning down a light source.

The frame is contrasted with the harmony of the tonal values, colours and lines of the picture."

Seurat first applied these theories to their full extent in *Invitation to the Sideshow*. The fact that horizontal lines dominate could, according to Superville, mean peacefulness. If, on the other hand, one considers the trombone pointing downwards, with its solemn, sombre tonal colour, the picture, with its dark, cold shades, establishes a rather sadder mood. This interpretation is confirmed by Gustave Kahn, who described this picture, which critics have generally tended to dismiss, as "of so choice a pallor and sadness".

In turning to the world of the circus and the café-concert for his subjects, Seurat was following a tradition established by the Impressionists. Inspired by the rise of urban entertainment in the 1860s, Edgar Degas (1834–1917) and Édouard Manet (1832–1883) in particular found novel subjects in *chanteuses* and their audiences. Café-concerts came into fashion during the Second Empire days of the 1850s. The Ambassadeurs, the Alcazar d'Été and the L'Horloge initially led the way, but were soon joined by a vast number of similar establishments that offered plays, operettas and other musical entertainments, as well as clowns, comedy acts and acrobats too.

In Degas' heyday, the most celebrated of these establishments was the Ambassadeurs, employing an orchestra of 15 to 20 musicians to accompany a show featuring roughly the same number of performers. A staff of between 15 and 30 waited on as many as 1200 customers having the best of times outdoors, under the trees, by gaslight. Recommended by the guidebooks, the Ambassadeurs, like the Folies-Bergère, became a meeting-point for Parisians and pleasure-seeking tourists alike. Both establishments were captured on canvas by artists of the time. Manet painted the *Bar at the Folies-Bergère* (1881; London, Courtauld Institute) and Degas the *Café-Concert at The Ambassadeurs* (p. 62). One star

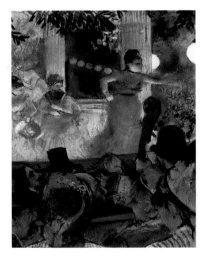

Edgar Degas
Café-Concert at The Ambassadeurs,
c. 1876–1877
Pastel on monotype, 37 x 26 cm
Lyon, Musée des Beaux-Arts

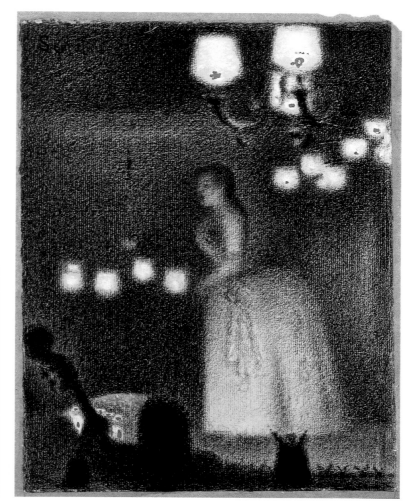

Café-Concert (À la Gaîté Rochechouart),
1887–1888
Conté crayon and white tempera highlights,
30.7 x 23.6 cm
Cambridge (Mass.), The Fogg Art Museum,
Harvard University Art Musem
Bequest of Grenville L. Winthrop

RIGHT:
Eden-Concert, c. 1886–1887
Conté crayon, 29.5 x 22.5 cm
Amsterdam, Van Gogh-Museum

favoured by Degas was Emélie Bécat, whose gestures and movements he im-
mortalized in numerous pastel studies and in *Mademoiselle Bécat at the Café
des Ambassadeurs* (p. 64). The songs may often have been crude, but the sexual
innuendoes titillated the audiences. The louche atmosphere is evocatively cap-
tured in Degas' pastels, which give a remarkably vivid sense of the *fin-de-siècle*
vaudeville scene.

Seurat did not simply turn to his Impressionist forerunners for inspiration, but
tasted for himself the distractions and diversions of Montmartre. His studio was
in the Boulevard de Clichy, quite close to establishments such as the Concert
Européen, the Rochechouart, the Divan Japonais and the Cirque Fernando. He
frequently also went to the café-concert L'Ancien Monde, whose shows ended
with the *chahut* – the noisy climax of the cancan which Seurat recorded in a
painting of the same name (p. 71).

Le Chahut differs from the preceding pictures in its astoundingly unclear per-
spective. Only the foreshortening of the face of the first dancer makes it evident
that we are viewing the scene from the perspective of the audience. Rising up

prominently from the lower edge of the picture is the double-bass player, viewed from the rear. As a dark figure in the foreground of the painting, he serves as a *repoussoir* (literally, a "pusher-back", from *repousser*, to push back), heightening our impression that the true subject of the painting lies deeper in the space beyond him. In this composition, too, Seurat for the first time overlaps his figures, something he had hitherto carefully avoided.

The rhythm of movement is evoked by the parallel arrangement of the legs, which also correspond to other diagonals in the painting. This method of depicting motion was of topical interest in Seurat's day due to the photographic studies of Étienne Jules Marey (1830–1904) and Eadweard Muybridge (1830–1904). The English-born American Muybridge became famous for his locomotion studies, from 1872 on, for which he used several cameras positioned next to each other and released in sequence in order to capture the movement of, for example, a horse. In 1883 Marey, a French physiologist inspired by Muybridge, developed a camera that made it possible to record a series of exposures on a single plate.

The parallel rhythmic lines that were to be seen in the resulting images provided Seurat with a starting-point for the composition of *Le Chahut*. The sense of dynamic movement is emphasized by the fan-shaped shadows cast by the legs on which the dancers are standing, and by the spiral lines in the gathered material of their skirts, which extend right up to the fan the first dancer is holding. The flow of the lines can once again be associated with the theories of Henry and Superville, according to which the lines moving upwards indicate a joyful, excited mood such as will doubtless have been occasioned by the entrance of the dancers.

These lines expressing motion also display a close relationship to poster art. Ever since childhood Seurat had had a special liking for popular illustrations, and this in part found its way into his pictures. The posters of Jules Chéret (1836–1932) were particularly popular in Seurat's time, for they featured bold, new graphics combined with colourful subject matter such as carnivals, the circus and vaudeville shows, and thrilling, rhythmic movement (cf. p. 51). Just as Chéret was valued for his style by Seurat and the avant-garde, so the café and vaudeville show provided the Impressionists in particular with new themes for painting, themes which they rendered in vivid fashion.

Seurat's *Le Chahut*, in contrast, appears more distanced and decorative despite the exaggerated movements. The caricature-like effect of the dancers is probably not solely a result of Chéret's influence, but arises from an impulse on the part of the artist to depict the make-believe world of the musical theatre with an ironic detachment.

This is confirmed by an analysis of the palette. To all appearances Seurat has fallen back on "dynamogenic" or warm colours here. But there are also dots of blue and green amongst the red and yellow shades, so that on closer inspection the colours appear broken. What we are being presented with is not a "natural" pleasure, therefore, but the artificially heightened thrill of such a performance. For the first time Seurat does not deploy his colours in accordance with Chevreul's rules. The complementary arrangements which can still be observed in the painted study (p. 68) are replaced by free, expressive shades of colour in the final version. The pointillist technique is also toned down. Instead, the paint is applied in elongated strokes in many places, following the contours. Seurat also drew an unbroken line around all the contours, in order to emphasize their two-dimensionality.

Edgar Degas
Mademoiselle Bécat at the Café des Ambassadeurs, 1885
Pastel on lithograph
New York, Collection of Mr and Mrs Eugene V. Thaw

PAGE 65:
At the Concert Européen, 1887–1888
Conté crayon on paper, 31.1 x 23.9 cm
New York, The Museum of Modern Art
Lillie P. Bliss Collection

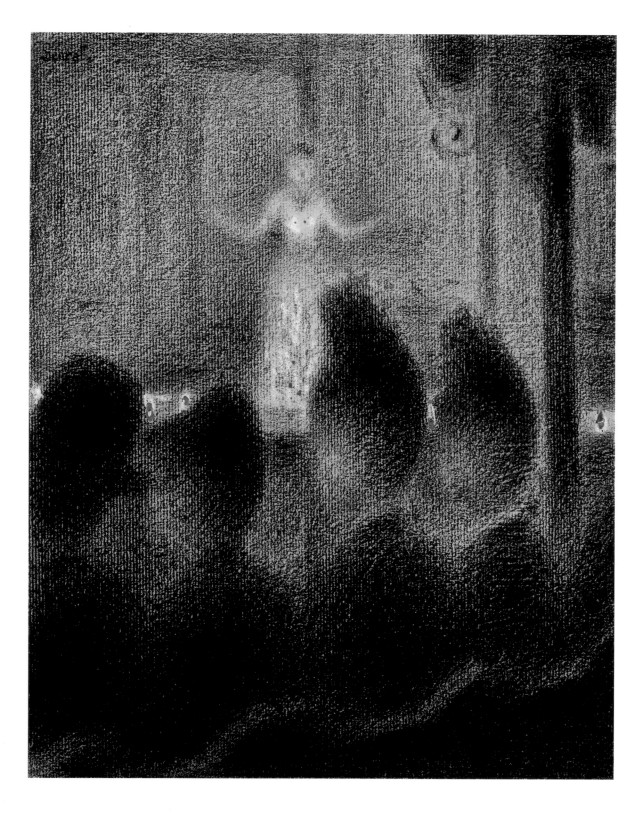

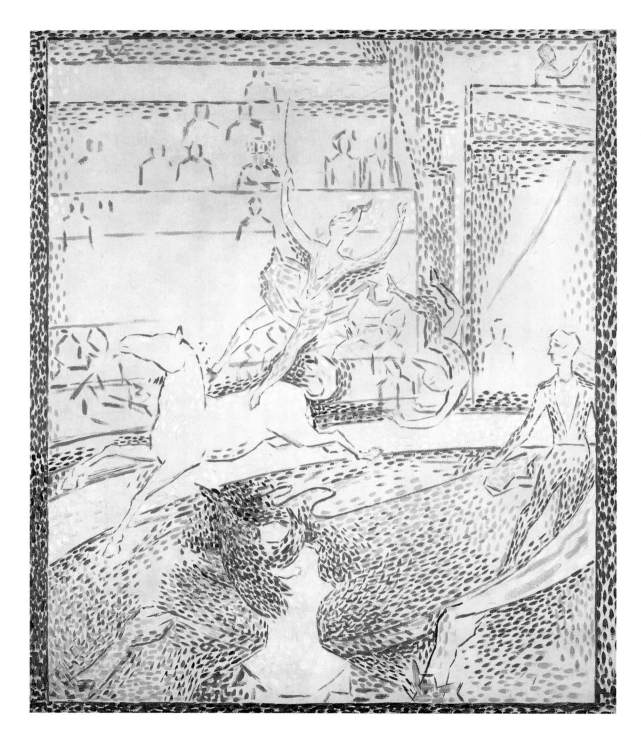

Study for *The Circus*, 1890–1891
Oil on canvas, 55 x 46 cm
Paris, Musée d'Orsay

Seurat also demonstrated his interest in the world of the café-concert in a series of his finest drawings. *Eden-Concert* (p. 63) was on show from March to May 1887 at the third exhibition of the Indépendants and was reproduced to illustrate an article by Kahn in the periodical *La vie moderne* in April 1887. In the centre is a singer whose curves are reiterated by the "dancing" gaslights. On the left rises the silhouette of a bass player – a motif that Seurat was to use again in his oil painting of *Le Chahut*. The drawing makes a very painterly impression due to the subtle gradation of grey tones and sharp contrasts of light and dark.

À la Gaîté Rochechouart (p. 63) depicts a similar situation. From his somewhat elevated position in the orchestra pit, the conductor with his raised baton is gazing at the singer, who is gesturing with her arms as she performs. Both drawings are based on the golden section, whereby *À la Gaîté Rochechouart* adheres even more closely to its laws of proportion. Seurat exhibited this latter drawing in 1888 at the Salon des Indépendants. It must have struck him as too regular and motionless to serve as a study for *Le Chahut*, however. The Conté crayon drawing *Au Divan Japonais* (p. 70), by contrast, is a direct preliminary study for *Le Chahut*, already developing its central motif. The Divan Japonais was somewhat more basic than the other two cafés, and Seurat sought to express this via a caricature-like style.

Most critics had reservations about *Le Chahut*. They felt the painting was too mechanical and lifeless, a feeling shared by the Dutch artist Vincent van Gogh (1853–1890), who visited Seurat in February 1888. Only the literary Symbolist circles in which Seurat and Signac moved during the 1880s saw, in Seurat's stylistic approach, a critique of the Parisian bourgeoisie and of the political conditions of the time. Gustave Kahn, for instance, described the contrast between the "beautiful dancer, this glory of a modest fairy" and the "ugly onlooker" as a "contemporary disgrace". Jean Ajalbert and Émile Verhaeren, two friends of Seurat, had written poems about the *chahut* and the café-concert in which they identified with the unconventional character of the actors and singers.

Seurat's *Le Chahut* can be read on many levels. A statement clearly critical of society is avoided, as is any "dynamogenic" glorification of the entertainment business or even a depiction of the cancan as an erotic metaphor. As in many of Seurat's later works, scientific rigour, a subjective and ironic view and a hint of symbolism are balanced by visual poetry and a not uncritical view of reality.

Seurat's main work of his later years, *The Circus* (pp. 2 and 50), is considerably less ambiguous. As it was not far from his studio, Seurat frequently went to the Cirque Médrano on the corner of Rue des Martyrs and the Boulevard Rochechouart. This circus, founded in 1875 and from 1890 onwards bearing the name of its most celebrated clown, was a favourite attraction for many artists, Seurat amongst them. There he studied the movements of the clowns, dancers and ringmasters. Going to the circus was a popular way of passing the time amongst Parisian avant-garde artists till well into the 20th century. The atmosphere, a combination of daring, danger and carefree cheerfulness, must have had a particularly stimulating effect on the artists of Montmartre, especially given the insecurities of their own lifestyles.

The horseback acrobatics which Seurat portrays were at the time among the *pièces de résistance* of the circus. The trainer put the horse through its paces using a long whip, and clowns contributed to the act by making cheeky comments and performing acrobatic gags. The public were seated around the ring. The seats in the various tiers were priced in line with the tiers in the social hierarchy.

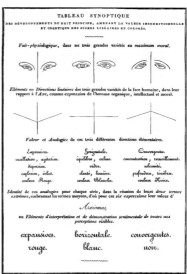

Humbert de Superville
Synoptic Table (illustrating the principles of his aesthetics)
From: H. de Superville, *Essai sur les signes inconditionnels dans l'art*, Leiden 1827

TOP:
Linear structure of **The Circus**
Diagram after: W. I. Homer, *Seurat and the Science of Painting*, Cambridge, Mass., 1964

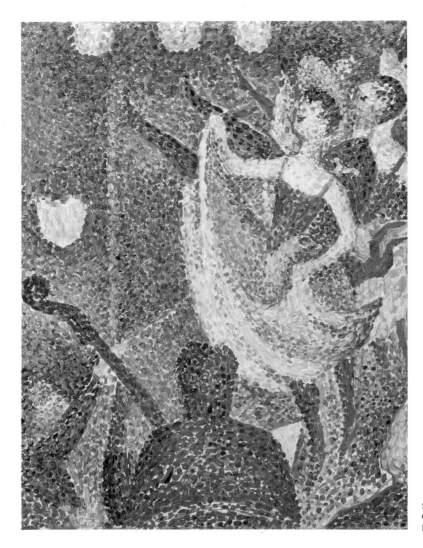

Study for *Le Chahut*, 1888–1890
Oil on panel, 21.8 x 15.8 cm
London, Courtauld Gallery

Seurat records these class distinctions in his picture with a sense of irony and humour: right at the top, in the gods, the workers are standing behind a balustrade wearing caps. Below are the second and third-class seats, to which Seurat assigns three rows. The five first-class rows have cushioned backrests, identifiable in the painting as crimson strips. Here sits a middle-class public which is not dissimilar to that in *La Grande Jatte*. According to Fénéon, the "onlooker with the funny top-hat" in the first row, to the left of the jumping clown, is the artist's friend Charles Angrand.

The composition differs from that of *Le Chahut* in its greater spatial depth. This sense of depth is reinforced by the rising white balustrade, the foreshortening of the horse and the female performer, and by the female audience members on the left who are seen from the side. Above all, however, it is established by the figure of the clown, whose size and powerful colours effectively force all the other motifs into the background.

PAGE 69:
Standing Model, c. 1887
Oil on panel, 25 x 16 cm
Paris, Musée d'Orsay

Au Divan Japonais, 1887–1888
Conté crayon, 30.5 x 23 cm
Paris, Musée d'Orsay

Seurat infuses his circus scene with extraordinary dynamism. The audience and horse are captured as if in a snapshot, while zigzag lines serve to express movement: a yellow ribbon is fluttering behind the dancer; at the entrance to the ring a band of colour darts like lightning. The trainer's snaking whip emphasizes the speed of the horse.

While Seurat's deployment of these features alluded to the new and popular poster art of Jules Chéret (cf. p. 51), he was still keeping to his organizational system of compositional structure. The squaring – parcelling up a surface with a grid as an aid to proportional design – is still visible in places between the dots. In relation to the horizontals in the picture, the diagonals all run at angles which correspond to even numbers (cf. diagram, p. 67). Henry termed such even numbers "rhythmic".

The expressive value of the lines corresponds to that of the colours. The newly developed system of short lines in *Le Chahut* is now applied more systematically. As the painting remained unfinished, they here possess a greater expressive force. The palette is governed by a bright yellow. One sole "inhibitory" colour, the blue in the contours and shadows, is countered by a multitude of "dynamogenic" colours: yellow, orange and red. The light colours, highlighted in white, are not muted by optical mixture. The distribution of colour underlines the "dynamogenic" effect of the picture. The red shirt and hat worn by the clown in the foreground rise up to the left in a "dynamogenic" movement which is greatly intensified by the movement of the dancer leaning to the right. The painted border is complementary to the palette of the painting and, owing to the strong light and dark contrast, creates the impression that we are looking through an opening in a curtain.

Although the painting was not yet finished, Seurat sent it to the spring exhibition of the Indépendants in March 1891. Compared with his other *toiles de lutte*, *Invitation to the Sideshow* and *Le Chahut*, this picture was easy to understand, and even amateurs who were not familiar with Henry's theories could appreciate it. Seurat was keen to strengthen his position as leader of the Neo-Impressionists – a position that seemed threatened both by his numerous imitators and by a passing disagreement with Signac.

In the long term, it was the appealing composition of *The Circus* that provided Seurat with his greatest success. Contemporary critics sang paeans to this painting: "What a powerful impression of radiant pleasure, what an undulating music of lines!" This was the picture upon which the Cubists and Constructivists later based their estimation of Seurat as the precursor of an art of pure expression.

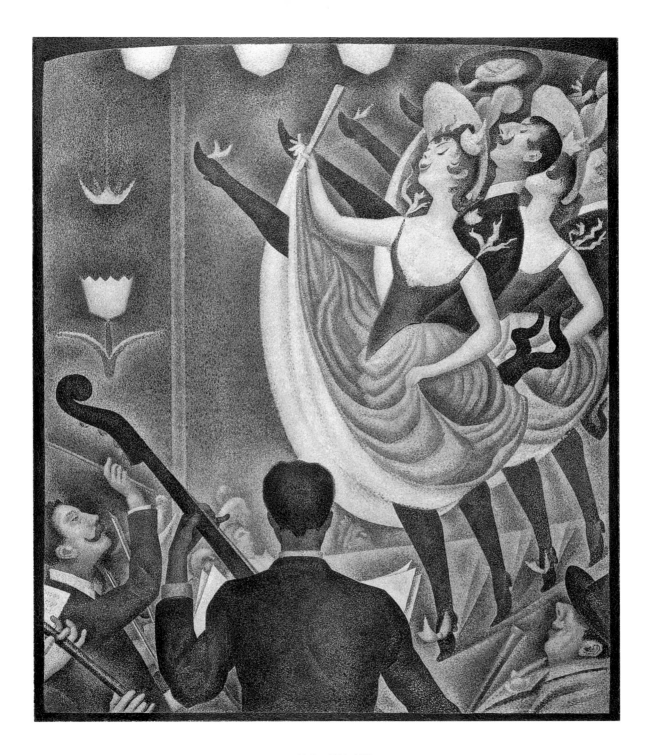

Le Chahut, 1889–1890
Oil on canvas, 169 x 139 cm
Otterlo, Kröller-Müller Museum

The Light of the Sea

From 1885 Seurat regularly spent a few weeks of the summer painting on the coast of Normandy and the Pas-de-Calais: he travelled to Grandcamp in 1885, Honfleur in 1886, Port-en-Bessin in 1888, Le Crotoy in 1889 and Gravelines in 1890. Only in 1887 did he remain in Paris, probably in order not to interrupt his work on his two large figure paintings, *Les Poseuses* (pp. 52/53) and *Invitation to the Sideshow* (pp. 60/61).

In this, Seurat was following in the footsteps of a long tradition of French painters, from Claude-Joseph Vernet (1714–1789) up to the forerunners of Impressionism, Eugène Boudin (1824–1898), Charles François Daubigny (1817–1878) and Johan Barthold Jongkind (1819–1891), who were the first to paint out of doors along the Normandy coast. They were followed in turn by Monet, who initiated *plein air* Impressionist painting with a series of simple beach scenes from seaside resorts popular at the time (e. g. *The Beach at Trouville*, 1870; London, National Gallery). The Normandy coast was within quick and easy reach thanks to the new railways and had become an attractive destination, not merely as a summer resort for rich Parisians but as a recreation area for ordinary citizens and tourists from England. Seurat's family regularly summered on the coast at Grandcamp, Les Petites Dalles and Mers-les-Bains.

In contrast to the agitated sea paintings from Etretat and Varengeville, in which Monet was expressing an elemental feeling for nature, Seurat's seascapes are marked by serene tranquillity and an all-permeating light. He was interested neither in the hustle and bustle of the ports nor in the colourful scenes on the beaches. Having experimented in Grandcamp with the pointillist technique, prior to lending it definitive expression in *La Grand Jatte*, Seurat subsequently turns his attention in his seascapes to the diverse moods created by the constantly changing light over the sea.

The series of seven paintings from Honfleur starts with a harbour view (*Quayside, Honfleur*, p. 72). The picture remained unfinished because the ships left their moorings. Although Seurat completed all his paintings in his studio, this indicates that his studies of the motif on location were absolutely essential to his work.

A large freighter is moored alongside the light quay wall, and its broad, dark hull with the funnel and slender soaring masts dominates the centre of the picture. On the right, the bows and jib boom of a large sailing ship are jutting into the picture. It is moored to a capstan on the quay wall with thick ropes. Despite the sketch-like character of the painting, the masts and the diagonal rigging running up to them have clearly been carefully arranged, giving the picture an "abstract" effect. Perhaps Seurat was also interested in the juxtaposition of steam

Léon-Auguste Asselineau
The Harbour Entrance, Honfleur (detail),
c. 1860, Lithograph

PAGE 72:
Quayside, Honfleur, 1886
Oil on canvas, 81 x 65 cm
Otterlo, Kröller-Müller Museum

The Channel of Gravelines, Petit Fort Philippe,
1890
Oil on canvas, 73 x 92.7 cm
Indianapolis (IN), Indianapolis Museum of Art
Gift of Mrs James W. Fesler in memory of Daniel
W. and Elisabeth C. Marmon

power and rigging, which since J. M. W. Turner (1775–1851) had been viewed as symbolic of the conflict between modern technology and out-dated tradition.

The unfinished state of *Quayside, Honfleur* enables us to reconstruct in some detail the artist's painting technique. In clear contrast to the Impressionist *alla prima* method, whereby the picture is painted in a single layer of paint with no underpainting, Seurat started by producing a precise preliminary drawing. Then he applied the first hues in elongated strokes, already taking the optical contrasts into account at this early stage. The colour of the surface of the water in the ship's shadow, for example, consists of red, green, light blue and turquoise layers of brushstrokes. The ship's three-dimensional hull was initially painted in an even dark blue, and then reworked with short strokes of red and blue. The light surfaces consist of irregular brushstrokes in pale shades that flow into each other. Only afterwards did Seurat introduce, in certain places, the pointillism which in his finished paintings covers the world of objects in a dense, unbroken surface.

While *Quayside, Honfleur* makes a contemporary and modern impression, almost a little too factual in the precise depiction of the rigging, two other

Les Bas-Butin, Honfleur, 1886
Oil on canvas, 67 x 78 cm
Tournai, Musée des Beaux-Arts

coastal scenes (pp. 75 and 76) from Honfleur show something of that timeless poetry of the sea which the Symbolist writers so greatly admired in Seurat's pictures. The Symbolist critics were less interested in the complex interplay of lines and colours; their attention was exclusively on the moods of the seascapes, which were unanimously taken to be at once gentle, muted and harmonious. Thus the art critic Joris Karl Huysmans (1848–1907), normally sceptical of Seurat's work, observed of his marine paintings in the *Revue Indépendante* in April 1887: "They draw once again on his view of a nature benumbed rather than melancholy, a nature at repose in the shadow of the winds and rendered lethargic beneath a motionless firmament." The writing style of the French poet Stéphane Mallarmé (1842–1898) is here transferred to art criticism, replacing the exact, objective description of a Fénéon with an account of subjective feelings. In this way Seurat's marine scenes became caught up in the wake of Symbolist visions, which sank the burdens of unrealized social utopias in the "calm infinity" of the sea.

In the painting *Le Bas-Butin, Honfleur* (p. 75), our gaze is directed past a steep cliff face, across the scrub and undergrowth, and out onto the open sea,

where two sailing boats and a steamer are moving past. The simplicity of the composition, the diagonal of the beach falling away towards the left, the horizon positioned roughly halfway up the picture, and the area of sky extending far above it, give the painting a majestic calm and harmonious balance. The most remarkable feature is the handling of colour, which occasioned the Symbolist poet Paul Adam (1862–1920) to comment that this was an "orchestra of symphonic dabs of colour". The eye perceives the full impact of the overall harmony and at the same time becomes engrossed in the delicacy of the vibrant colour values, described by Adam as "fleeting hues of malachite and emerald, and also lapis lazuli, with the heavens gleaming like a large bowl studded with tiny gems".

What Adam praises in these seascapes is above all the consequence of Seurat's further development of his pointillist technique, namely to a point where it no longer endeavoured to achieve an "optical mixture" that was true to theory, but gave the individual hues more freedom to unfold their own intensity and brightness. The concept of a "symphonic" palette was an offshoot of the

Evening, Honfleur, 1886
Oil on canvas, 65.4 x 81.1 cm
New York, The Museum of Modern Art
Gift of Mrs David M. Levy

Port-en-Bessin, Entrance to the Harbour, 1888
Oil on canvas, 54.9 x 65.1 cm
New York, The Museum of Modern Art
Lillie P. Bliss Collection

enthusiasm for Wagner that was sweeping Paris at the time, and which culminated in the establishment of a *Revue Wagnérienne*. Wagner's innovative interweaving of harmony and melody, his use of leitmotifs and his unusually opulent orchestration inspired Symbolist circles to proclaim a "Wagnerian art", a concept which they not infrequently extended to Seurat's painting. How seriously these theories on the fusion of music and painting were occasionally taken can be seen in the example of Signac's seascapes, which were given musical titles (opus numbers) and keys. Though Seurat himself moved intermittently in these eccentric circles of literati and artists, who gathered in the editorial office of the *Revue Indépendante* to exchange ideas, such romantic extravagance was not for him. The only leitmotif he identified for his marines was "plus d'éclat" (more brilliancy), light as a metaphor for freedom and vast expanses, as he put it to Signac in a letter from Honfleur: "What else should I report? – believe me, that is all for today; let us once more become intoxicated with light, it comforts."

Even more impressive is the painting *Evening, Honfleur* (p. 76). With its shoreline shelving off to the right, it seems a companion piece to *Le Bas-Butin, Honfleur* (p. 75). The evening sun is filling the picture with a warm, refracted light, with which the varied nuances of colour accord. The shore area in particular, with its large, irregular dabs of paint, offers a shimmering interplay of orange and violet which offsets the turquoise surface of the ocean. Dark blue banks of cloud thrust their way into the expansive yellow sky from the right. The few solid objects in the picture, such as the piles and rock in the foreground, combine effectively into a calmly structured rhythm.

Evening, Honfleur is one of three paintings in which the painted frame which Seurat added to all his later pictures has survived. Its colour is deliberately chosen to be complementary to the palette employed for the painting: since the picture is dominated by yellow, the frame is thus governed by violet. Despite this, the contrast is not harsh or unpleasant, as the colours in the frame alternate

Port-en-Bessin, 1888
Oil on canvas, 67 x 84.5 cm
Minneapolis (MN), The Minneapolis
Institute of Arts

PAGE 79:
Port-en-Bessin (detail), 1888
Oil on canvas, 67 x 84.5 cm
Minneapolis (MN), The Minneapolis
Institute of Arts

in intensity and brightness. Where the picture is light, the frame is dark, and
vice versa. The contrasts of light and dark between picture and frame constitute
a dynamic visual stimulus which attunes the eye to the effect of light in the
picture.

The problematic issue of the framing of pointillist pictures had been raised
by Fénéon on the occasion of the 1886 Indépendants exhibition. Since the
customary gilt frame marred the delicate oranges and yellows in pointillist
paintings, Fénéon suggested they should adopt the white frame favoured by the
Impressionists. Seurat, however, found the contrast between harsh white and his
subtle palette too stark. Starting with his seascapes, he now began to paint his
own frames, too, in contrasting colours applied using the same pointillist tech-
nique as the actual picture. He would later also paint a narrow border onto the
canvas around the image proper – a thin strip of colour intended to reinforce
the complementary impact of adjacent colours.

The atmospheric paintings of Honfleur earned Seurat the undivided acclaim
of the critics and the public for the first time, and ensured that the Neo-Impres-
sionists were now considered acceptable, at least where landscapes were
concerned.

Port-en-Bessin, Sunday, 1888
Oil on canvas, 66 x 82 cm
Otterlo, Kröller-Müller Museum

In the summer of 1887, Seurat worked without interruption on the large figure paintings of *Les Poseuses* (pp. 52, 53) and *Invitation to the Sideshow* (p. 60/ 61). Not until August 1888 did he return to Normandy. This time he chose Port-en-Bessin, which had already provided Signac with motifs for his seascapes in 1882. The pictures which Seurat began on location were then completed in Paris during the winter of 1888/89 and exhibited as a group of six marine scenes at the sixth show of the Brussels group "Les Vingt" in February 1889.

Port-en-Bessin is even less spectacular a place than Grandcamp or Honfleur. In addition, Seurat chose a high vantage point over the docks for some of his paintings, in order to avoid the excessively dramatic. In terms of composition, these pictures are influenced by the Japanese colour woodcuts which were then a focus of interest in artistic circles, and which were inspiring a new, more two-dimensional approach to composition.

Despite the realism of the setting, which can be confirmed from contemporary postcards, *Port-en-Bessin* (p. 78) makes a highly artificial impression, as if the Sunday calm had been preserved for posterity under glass. Beyond a large, brightly lit area in the foreground, a swing bridge directs our gaze to a row of simplified box-like houses which cast long, sharp shadows. The background is a high cliff covered in grass, above which is a bright sky studded with spherical

clouds. The building on the right – a pavilion from which fish was sold – has an almost exotic air. Viewed in close-up, its filigree pillars exhibit an admirably fine pointillist technique, and display the manifold nuances of colour which Seurat used to convey a particular impression of light (p. 79). The people in the painting – just three figures in the foreground: a customs official, an old woman with a basket on her back and a child looking out of the picture – do not serve to enliven the picture, but through their curious stiffness almost appear to be extensions of the architectural elements. This impression of "frozen time" is further heightened by the shadows cast by the figures and houses, which border on the abstract and lend the painting a mysterious atmosphere reminiscent of the *pittura metafisica* of Giorgio de Chirico (1888–1978).

A similar mood prevails in the painting of *Port-en-Bessin, Sunday* (p. 80). We are looking from a parapet onto the harbour with a channel through to the roadstead and the sea beyond. Seurat composes a visual rhythm with a musical metre out of the harbour architecture. The balustrade in the foreground leads us into the theme: two houses of similar appearance establish a rhythm which is picked up by the rounded niches of a wall on the right and recapitulated in the tall dark block of a warehouse on the edge of the picture. Contrapuntal to this are the fluttering flags in red, blue and green on the masts of the cutters. This is the only undulatory movement to break the angular composition, and heralds the curved lines typical of Seurat's late work.

Port-en-Bessin, Entrance to the Harbour (p. 77) is a potent illustration of how Seurat takes an otherwise naturalistic scene and condenses it into its essentials in favour of a compact, harmonious composition. We are looking onto a sandy strip of coastline that slopes away towards the background and has small clumps of grass growing on it. Seurat renders these as even, dark islands in the light sand, thus structuring the foreground in the same manner as the broad expanse of the ocean, onto which the clouds cast their shadows in the form of darker ovals. Another notable feature of this painting is the sense of spatial depth it achieves – despite the decorative two-dimensionality of the treatment of the grass and cloud – by the skilful positioning of the sailing boats, which gradually vanish into the distance. This ornamental structuring of the picture is once again reminiscent of Japanese colour woodcuts, and highlights the increasing tendency amongst the Parisian avant-garde of the day towards stylization and abstraction, as can be seen in the work of many Post-Impressionist artists, such as those making up the Nabis.

This group of artists, which formed around Paul Sérusier (1864–1927) in 1888, brought together students of the Académie Julian in Paris, such as Maurice Denis (1870–1943) and Henri-Gabriel Ibels (1867–1936), and artists such as Edouard Vuillard (1868–1940) and Pierre Bonnard (1867–1947). Their collective aim was to develop a decorative style which emphasized the flat surface, in contrast to Impressionism's dissolution of form. The name Nabis (a Hebrew word meaning "prophets") symbolizes the mystical, semi-religious leanings of the artists, who indulged in endless philosophical and intellectual discussions with one another.

Following the sixth exhibition by the Indépendants, Seurat travelled to the coast for the final time in the summer of 1890. The Neo-Impressionist group was threatening to be torn apart by petty jealousies, and Pissarro had completely turned his back on the technique. Seurat's latest paintings, *Le Chahut* (p. 71) and *Young Woman Powdering Herself* (p. 57), had been unfavourably received. He had recently started living a secluded life with Madeleine Knobloch and their

child in a studio in the Passage de l'Élysée-des-Beaux-Arts. Despite the pressures upon him, in Gravelines Seurat painted four seascapes of great purity and filled with light. The visual geometry of these oils appears even more serene and tranquil than that of the preceding marine pieces. Rocks and vegetation have disappeared. Instead, the composition is constructed of a few carefully placed elements, mainly boats and their superstructures. All the paintings have a dark-coloured border which has been dabbed onto the canvas. The colourful frame proper has only survived in the case of *The Channel of Gravelines, Petit Fort Philippe* (p. 74), where it once again complements the palette of the painting, both in terms of colour and in the offset of light and dark.

In this painting, Seurat achieves a clarity and calm which, going far beyond the objectives of the Neo-Impressionists, anticipates abstract trends in art. Our gaze sweeps across the channel with the moored fishing boats to the small town of Petit Fort Philippe, which ends on the left with the towering lighthouse. From the foreground, a jetty curves away into the right-hand background. Capstans are positioned along it at regular intervals, the nearest precisely on the central axis of the painting. The centre of the composition is marked by a white sailing boat.

Port-en-Bessin, Outer Harbour at Flood Tide
1888
Oil on canvas, 67 x 82 cm
Paris, Musée d'Orsay

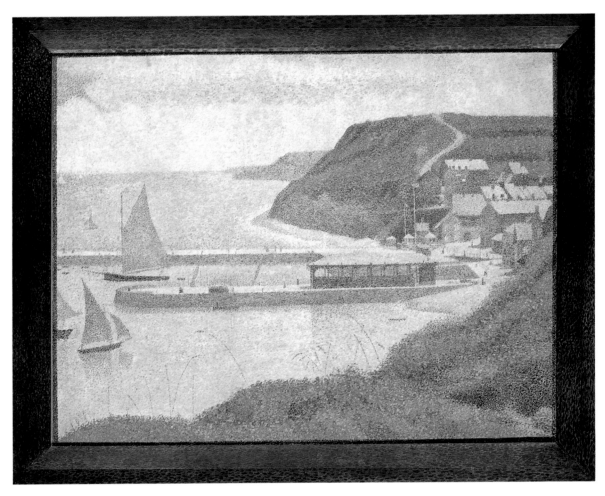

The Channel at Gravelines, Evening, 1890
Oil on canvas, 65.4 x 81.9 cm
New York, The Museum of Modern Art
Gift of Mr and Mrs William A. M. Burden

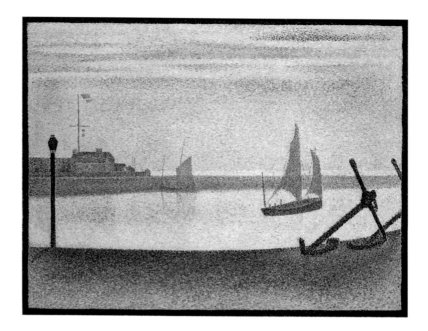

The jetty, which curves from bottom left to top right, appears to relate to the theory propounded by Charles Henry, according to which lines pointing upwards, and the tips of angles pointing to the right, are considered extremely "dynamogenic". The yellow, orange and red of the jetty also match this theory. The complementary luminous blue-green of the water emphazises the early morning mood of the colours.

As after most of his summer breaks, Seurat returned from Petit Fort Philippe, too, with an atmospheric painting of evening. In this case it almost seems a premonition of his imminent death at the height of his artistic career. *The Channel at Gravelines, Evening* (above) shows a deserted breakwater with a view across the channel onto the open ocean. The view is bounded on the left by a lamp-post and on the right by two parallel anchors. In the background on the left is a building with a signal mast, the vertical line of which is picked up by a sailing boat moored in front of it. On the right a larger boat is setting out to sea. In the tradition of the German Romantic painter Caspar David Friedrich (1774–1840), this motif might readily be interpreted as a symbol of death or transcendence, especially as the related drawings show the boats travelling in a similar direction towards the open sea. Nuances of red and green modulate the light to create subtly coloured hues. The calm of the vertical lines is interrupted by the anchors pointing to the right, the direction to be taken by the departing cutter – into the open, the unknown.

Pointillism and its Consequences

Seurat's sudden death in 1891, following a febrile angina, created considerable consternation amongst his friends and followers. He was considered to be a great innovator in painting, whose early death brought to nothing the many ideas and plans which he had confided to a few of his friends.

The Neo-Impressionist group was thereby itself rife with tensions and petty jealousies, which only the previous year had caused Seurat to write a strongly-worded letter to Fénéon in which he insisted upon his leading position in the invention of pointillism. The occasion was an essay by Fénéon on Signac (*La Peinture Optique: Paul Signac*), in which the critic had gone into the optical mixture and colour theories of the Neo-Impressionists without so much as mentioning Seurat.

The main reason why Fénéon had sided with Signac was that the latter, at quite an early stage, had started working with the art theoretician Charles Henry, whom Fénéon regarded so highly that he had penned an enthusiastic review of his theories. Seurat drew inspiration from Henry and was very interested in his ideas, but at the same time felt constricted by his massive influence. For this reason he did not mention Henry in his own *Aesthetics*, although certain phrasing refers to him and his theories can be demonstrated to have found their way into Seurat's paintings. Seurat saw himself as the pioneer of a scientific painting based on objective principles and defined rules.

Illuminating in this regard is a small canvas which Seurat executed in 1889, showing the still unfinished Eiffel Tower (p. 84). The Tower was at that time painted in bright enamel, which only served to heighten the revulsion for the structure felt by conservative-minded artists. Seurat swathes the Tower and its rising diagonals in "dynamogenic" red and yellow dabs of colour, establishing a formal analogy between pointillism and the new construction method using prefabricated parts. Seurat thereby draws upon an established range of components (points and lines) out of which to build a whole. The choice of motif clearly reveals Seurat's avowal of technology and progress, which he wanted to contribute to, in the field of art, through his pointillist method. But Seurat's concept of art was not informed by a naïve belief in progress in the sense of the positivism predominant at the time. Rather, Seurat and his friends were devotees of a psycho-physiological type of aesthetics. They were convinced that the rhythms of colour and form in a picture had a direct effect on the psyche and refined one's sensitivities, in other words moulded and "ennobled" man from within, a belief that was later to become an important core idea in abstract painting.

But without Seurat's inquiring mind the Neo-Impressionist movement in France and Belgium had little persuasive power, even if many artists employed

PAGE 84:
The Eiffel Tower, 1889
Oil on canvas, 24.1 x 15.2 cm
San Francisco, The Fine Arts Museum
of San Francisco

the style in a relatively superficial manner. Even Camille Pissarro, who had initially been fully convinced by pointillism and painted some of his best works in the pointillist manner (p. 88), soon turned away in disappointment in order, once again, to devote himself to atmospheric landscape painting in the style characteristic of the Impressionists.

It fell to Paul Signac to fill the painful gap in the circle of pointillism's supporters with new vigour and enthusiasm. After initial discouragement and a retreat to Brittany, he returned to work and, above all from 1895 onwards, created a series of masterpieces in which he translated the landscape of southern France into compositions glowing with colour. A new hallmark of these pictures is the strength and autonomy of the luminous colours which, enlarged to small squares the size of mosaic stones, unfold their complementary potential all the better (p. 87). The other new departure lay in the relationship with nature, which for Seurat had still been an indispensable prerequisite of painting, but which, for Signac, merely provided the motifs which triggered the symphonies of colour he created in the studio.

In 1899 Signac's book *From Eugène Delacroix to Neo-Impressionism* appeared, in which he sought to elucidate the Neo-Impressionist method of painting by means of numerous references to precursors (Delacroix, the Impressionists) and contemporary theories (Chevreul, Blanc, John Ruskin, Rood). "Optical mixture" is also mentioned, but other than in previous accounts it

Henri Edmond Cross
The Golden Islands, 1891–1892
Oil on canvas, 60 x 55 cm
Paris, Musée d'Orsay

Paul Signac
The Papal Palace, Avignon, 1900
Oil on canvas, 73.5 x 92.5 cm
Paris, Musée d'Orsay

is not related directly to pointillism. The *touche divisée* (divisionist application of colour) does not have to be dot-shaped and small in order to create colour harmonies.

According to Signac, the primary goal of Neo-Impressionist painting is to make colours as similar to light as possible and to create as great a luminosity as possible, without dulling it by mixing pigments on the palette. Colour thereby moves clearly away from empirical observation and is "refined" into an autonomous hue independent of its ostensible motif, a process exemplified in the paintings of Signac and Henri Edmond Cross (1856–1910; cf. p. 86) dating from these years.

The palette of Cross's works is bright and full of contrasts, and his brush-strokes are broad and of equal force. They go beyond concrete connections to perceived subjects and evolve their own dynamics in sweeping, flowing movements. Their immediacy of form and colour made a great impression on Henri Matisse (1869–1954), who spent the summer of 1904 with Signac in Saint-Tropez and frequently visited Cross in nearby Saint-Clair. The painting *Luxe, Calme et Volupté* (p. 90), which Matisse began at that time and completed during the winter, would not be conceivable without the influence of the cellular colour intensities of Signac and Cross. In Matisse's works, however, these movements

Camille Pissarro
Spring Sunshine on the Meadow at Eragny,
1887
Oil on canvas, 54.5 x 65 cm
Paris, Musée d'Orsay

and contrasts are no longer integrated into a comprehensive composition, but are arranged in an even more contrastive and direct manner, whereby the white ground makes an essential contribution as the foil for these colour dynamics. Later Matisse compressed the juxtaposition of small touches of colour into solid larger areas of colour, and increased the dynamism and multivalency of the colour contrasts, without ever entirely abandoning the representational world of objects.

Similarly, Paul Gauguin (1848–1903) and the Nabis continued developing the autonomy of colour by intensifying the forms and colours recorded in front of the motif into an independent synthesis in their pictures. *Talisman (Landscape in the Bois d'Amour near Pont-Aven*, 1888; Paris, Musée d'Orsay), painted by Paul Sérusier following a conversation with Gauguin in 1888 and a picture which anticipates the synthetic painting of the Nabis (Maurice Denis, Édouard Vuillard, Pierre Bonnard and others), is a free colour composition in which the local colours are intensified into powerful contrasts.

Robert Delaunay (1885–1941) probably drew the most radical conclusions from the theories of the pointillists, insofar as he constructed his compositions out of colour contrasts alone, without using any motifs at all as his points of departure. This is demonstrated in his *Windows* series dating from 1912 onwards. In his early pictures of 1906/07, influenced by the Neo-Impressionists, Delaunay took up the ideas of Signac and Cross and created a mosaic of colour dynamics, using individual, clearly defined and richly constrasting cells of colour. *Landscape with Disk* (p. 92) exhibits vivid colours in restless collision with each other, causing the eye to make rapid movements that in turn cause the colours, as they meet, to change and destabilize each other. His familiarity with Neo-Impressionist theory, probably from reading Signac's book, is demonstrated by the white centre, which is surrounded by violet rings and is intended to invoke the complementary yellow (the sun) purely physiologically in the process of

seeing. Delaunay also adopted the term "simultaneous contrast", coined by Chevreul, in his writings, though he charged it with a new meaning which went far beyond optical perception. For him, the simultaneity of interacting colour stimuli, which can only be experienced with the eye, became a model of the "vital movement of the world". Delaunay felt that colour events were global events. The process of seeing triggers a process of analogy which is taken to metaphysical heights. In Delaunay's case, however, the elevation of "pure colour" to an instrument of universal insight is almost completely lacking in any substantiation in terms of the science of colour. Apart from a few stray references to Chevreul and Rood, his writings contain no elaborate colour theories concerning the "synchronous movement of light".

The Italian Futurists, Delaunay's rivals in the development of the simultaneous dynamics of colour, also went through a Neo-Impressionist phase before vociferously proclaiming their own contribution to modern art in Paris. But even in this heady time of new departures, an artist such as Giacomo Balla (1871–1958) was able to remember his roots and depict a rhythmical sequence of movements composed of dots of colour, where the Futurists would normally have used crystalline forms. Here, though, the intrinsic value of the colour is repressed by the pattern of repetition and mutation. In Balla's paintings, it is not

Alfalfa, La Lucerne, Saint-Denis, c. 1884–1885
Oil on canvas, 65 x 81 cm
Edinburgh, National Gallery of Scotland

the energy of the colour contrast that is decisive, but the thrusting dynamism of the patches of colour.

Within a few years Signac's "second Neo-Impressionism" had developed into a new method of painting with prismatic colours and equally-fashioned cell structures, one which numerous artists throughout Europe used, for a short time at least, in order to pass beyond the analysis of colour and subject and attain their own styles. The trend towards abstraction that was already visible in Seurat's works became increasingly more pronounced until, at the beginning of the 20th century, it became a widespread artistic goal. Both Wassily Kandinsky (1866–1944), the founder of abstract art, and Piet Mondrian (1872–1944) went through a brief Neo-Impressionist process of orientation before setting out along the path of pure colour and autonomous form.

This was, of course, not merely owing to Signac, who during his long life was on view at many European exhibitions during these years. But it was above all his powerfully coloured pictures from 1895 onwards which pointed the way to autonomous colour, rather than the paintings of Seurat, which were by contrast rather grey and formalistic. Even while Seurat was still alive, critics, including Signac, had disapproved of the over-emphasis on theory in his paintings, which was at variance with the effect they were intended to produce. In this they forgot that Seurat was concerned not with the dogmatic application of pointillism, which soon after his death was already being transformed by most of the Neo-Impressionist painters into their own individual styles of large patches or irregular dabs, but above all with the synthesis of its elements into a harmonious equilibrium, as evidenced by his best works.

For years Seurat was well-nigh forgotten, and certainly undervalued, and only more recently have we again learned not to view his works as the legacy of a cerebral aesthete somewhat cheated by life, but as a fundamental contribution

Henri Matisse
*Luxe, **Calme et Volupté***, 1904
Oil on canvas, 98.5 x 118.5 cm
Paris, Musée d'Orsay

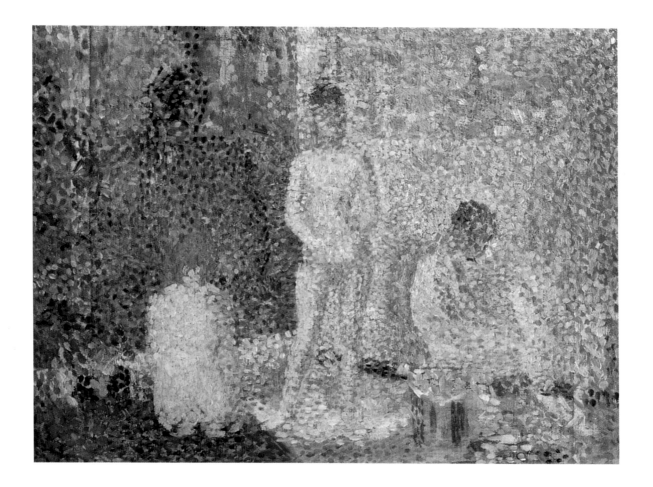

Study for *Les Poseuses*, 1887
Oil on panel, 15.5 x 21.5 cm
Private Collection

towards the treatment of painting as a "pictorial science", something that has borne fruit in the 20th century in so many different ways, as for example in Analytical, Radical and Essential art.

Seurat's impact on the evolution of modern art can only be assessed if his paintings are not merely seen as the stringent consequence of a technique derived from Impressionism, but are taken as diverse expressions of a multi-faceted output. From his earliest work on, a determination to stylize and to render the world of physical objects in rhythmic fashion is palpable. In this he was a precursor of Art Nouveau and Art Deco. But the autonomy of pictorial means which he evolved from an extreme observation of nature and from his theoretical reading had farther-reaching consequences. Via Matisse and the Fauves, through Futurism and Cubism, it ultimately led to abstraction. The works of Robert Delaunay, Oskar Schlemmer (1888–1943), Piet Mondrian, and the De Stijl group, founded in 1917 in the Netherlands, all bear witness – in the absolute value placed upon "abstract" structural imperatives – to their great predecessor.

Just a few years after Seurat's death, Signac penned a remarkable tribute in his journal, to which there is nothing to be added: "How unfair people are about Seurat. They refuse to recognise him as one of the geniuses of our century! The

young are full of admiration for Laforgue and van Gogh – they are both dead (would they be admired otherwise?). But Seurat: forgotten, silence. Yet he is a greater painter than van Gogh, who is only remarkable as a psychological phenomenon […]. At the time of Seurat's death the critics did justice to his talent, but decided that he had not left any completed works! On the contrary, I feel that he gave everything he could give, and admirably at that. He would surely still have created much and continued to progress, but his task had already been completed. He was interested in everything and achieved definitive results in the fields of black and white drawing, the harmony of lines, of composition, of contrast, and the harmony of colour … and even in that of the frame. What more can one ask of an artist?"

Robert Delaunay
Landscape with Disk, 1906
Oil on canvas, 55 x 46 cm
Paris, Musée national d'art moderne,
Centre Georges Pompidou

PAGE 93:
The Couple (Study for La Grande Jatte), 1884
Oil on canvas, 81 x 65 cm
Cambridge, Fitzwilliam Museum

Life and Work
Georges Seurat
1859–1891

1859 Georges Pierre Seurat was born on 2 December at 60 Rue de Bondy in Paris. His father, Chrysostome-Antoine Seurat, had been a legal official in La Villette. He had saved a substantial amount of money and lived a secluded life as a pensioner in his summer house in Le Raincy and in a flat in La Villette. He visited his family, which had been living at 110 Boulevard Magenta since 1862, just once a week. Seurat's mother, Ernestine Faivre, came from a prosperous middle-class Parisian family. She and her son were very close.

1869–1876 During his schooldays, Seurat was introduced to painting by an uncle on his mother's side, the textile dealer Paul Haumonté-Faivre, himself an amateur painter.

1875–1877 Seurat attended a drawing class taught by the sculptor Justin Lequien at a night school in the city. There he made friends with Edmond Aman-Jean. In 1876 he studied the *Grammaire des arts du dessin* by Charles Blanc.

1878 Seurat was admitted to the École des Beaux-Arts in February, together with Aman-Jean, and on 19 March joined the painting class taught by Henri Lehmann, a pupil of Jean Auguste Dominique Ingres. Seurat studied the old masters in the Louvre.

1879 He left the École des Beaux-Arts and, together with Aman-Jean and Ernest Laurent, rented a studio in Rue de l'Arbalète. In November Seurat started his year of military service in Brest. In his sketchbook, in addition to numerous sketches of figures, he drew studies of the sea, beach and ships, and read David Sutter's work on the *Phenomena of Vision*.

1880 After returning from Brest on 8 November, he rented a small room at 19 Rue de Chabrol, not far from his parents' flat, where he painted his most important works up till 1886.

1881 Seurat read the colour theories of Ogden N. Rood and studied the paintings of Eugène Delacroix. Together with Aman-Jean, he made numerous trips into the environs of Paris.

1883 For the first and only time, Seurat was represented in the official Salon by a drawing of *Aman-Jean*. That same year, Seurat met Pierre Puvis de Chavannes.

Lehmann's class, 1878
(Seurat is 6th from left)

TOP:
Ernest Laurent, **Portrait of Seurat**, 1883
Charcoal, 39 x 29 cm
Paris, Musée du Louvre

PAGE 95 TOP LEFT:
Signac, 1889–1890
Conté crayon, 36.5 x 31.6 cm
Paris, Private Collection

PAGE 95 CENTRE RIGHT:
Maximilien Luce, **Seurat**, 1890
Charcoal and watercolour, 25 x 21 cm
Paris, Private Collection

PAGE 95 BOTTOM LEFT:
Letter from Seurat to Maurice Beaubourg,
28 August 1890, Paris, Private Collection

PAGE 95 BOTTOM RIGHT:
Paul Signac
Felix Fénéon, 1890, Oil on canvas, 73.5 x 92.5 cm,
Private Collection

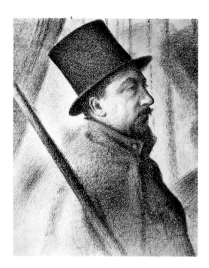

1884 Seurat's first large painting, *Bathers at Asnières*, was rejected by the Salon. In May, however, it was shown in the exhibition held by the Société des Artistes Indépendants. It was here that Seurat became acquainted with Paul Signac, with whom he soon became close friends. In December he exhibited the first studies for *A Sunday on La Grande Jatte* with the Indépendants.

1885 Having spent all winter working on *La Grande Jatte*, Seurat completed the painting in March. Through Signac he was introduced to the artistic avant-garde and the Symbolist literati. He spent the summer in Grandcamp in Normandy.

1886 Seurat exhibited *La Grande Jatte* at the eighth and final Impressionist exhibition. The art critic Félix Fénéon subsequently wrote an informed analysis of Seurat's technique and style. Through Fénéon Seurat got to know the young mathematician and art theoretician Charles Henry, whose theories made a consider-able impression on him. Seurat spent the summer in Honfleur. He exhibited ten works in the Indépendants show which opened on 26 August, including *La Grande Jatte*. The Belgian poet Émile Verhaeren invited him to the next exhibition to be held by the Brussels avant-garde group "Les Vingt". In the autumn Seurat worked on *Les Poseuses* in his new studio at 128b Boulevard de Clichy.

1887 On 2 February Seurat took part, with Signac, in the opening of the "Les Vingt" Salon in Brussels, where he exhibited seven paintings, including *La Grande Jatte*. At Signac's instiga-tion, those artists using the pointillist technique formed themselves into a group of Neo-Impres-sionists; they included Albert Dubois-Pillet, Charles Angrand, Maximilien Luce and, for a short period, Camille and Lucien Pissarro. In March Seurat exhibited studies for his new painting, *Les Poseuses*, at the Indépendants show. During the summer he worked on this painting and on *Invitation to the Sideshow*, which was influenced by Henry's aesthetics.

1888 In January Seurat and his friends held an exhibition in the rooms of the *Revue Indépen-dante*, which was headed by Fénéon. He spent the summer in Port-en-Bessin on the Normandy coast, where he produced numerous seascapes.

1889 In February Seurat once again took part in the exhibition held by "Les Vingt" in Brussels. Irritated by internal disagreements, he started to withdraw from his friends. He met the model Madeleine Knobloch, and in October they started living together in a studio in the Passage de l'Elysée-des-Beaux-Arts.

1890 Their son Pierre Georges was born on 16 February. Seurat exhibited *Le Chahut* and *Young Woman Powdering Herself*, a portrait of Madeleine Knobloch, at the Indépendants. Jules Christophe devoted a booklet to him in the series *Les Hommes d'Aujourd'hui* edited by Fénéon. Seurat spent the summer months in Gravelines on the North Sea, painting more seascapes.

1891 On 7 February, the Salon of "Les Vingt" opened in Brussels with, amongst others, *Le Chahut* and six landscapes by Seurat. On 16 March Seurat exhibited the unfinished *Circus* in the Salon des Indépendants. On 29 March he died of an infectious angina. He was buried two days later in the Paris cemetery of Père Lachaise. His son died shortly afterwards of the same infection.

On 3 May an inventory was taken of his estate by Paul Signac, Maximilien Luce and Félix Fénéon. Madeleine Knobloch received a number of paint-ings as her portion of the inheritance. Following quarrels, she severed all contact with Seurat's family for good.